Andrew Dasburg

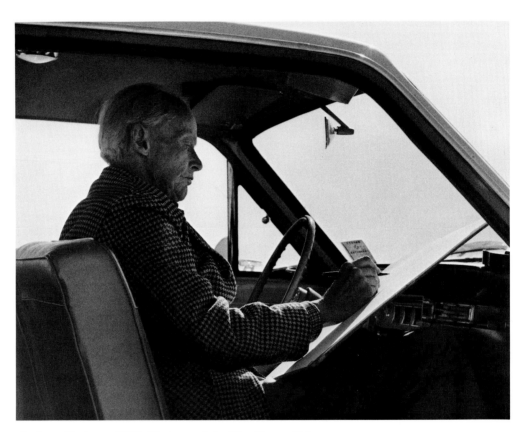

Andrew Dasburg, 1965. Photograph by Van Deren Coke.

Andrew Dasburg

Van Deren Coke

UNIVERSITY OF NEW MEXICO PRESS *Albuquerque*

Library of Congress Cataloging in Publication Data

Dasburg, Andrew, 1887–
 Andrew Dasburg.

 Includes bibliographical references and index.
 1. Dasburg, Andrew, 1887– 2. Painters—
United States—Biography. I. Coke, Van Deren, 1921–
joint author.
ND237.D25A4 1979 759.13 [B] 79-4931
ISBN 0-8263-0516-4

First edition

Preface

It was with great sadness that I learned on August 13, 1979, that Andrew Dasburg died in Taos in his ninety-second year as this tribute to his achievements was going to press.

This book would have been impossible to write without the continuous and generous help given me by Alfred Dasburg. For this assistance I wish to express my deepest appreciation. Thanks are also due Earl Stroh, who read the manuscript and offered valuable suggestions about the treatment of various aspects of Dasburg's life. I also want to express my appreciation to the owners of the paintings and drawings I have reproduced for letting me do so. A National Endowment for the Arts grant provided some of the funding for the color plates. This gives the book a truer reflection of the artist's achievements. Mrs. Leo Wolman also helped to make the color plates possible and therefore to represent better the work of her old friend Andrew Dasburg. To her I extend my warmest thanks.

Contents

Illustrations

FIGURES

PLATES

Andrew Dasburg is "the greatest draughtsman of landscape since Van Gogh."[1] This was the judgment of the well-regarded critic and art historian Alfred Frankenstein, reviewing for the *San Francisco Sunday Examiner and Chronicle* a retrospective exhibition of the drawings of Dasburg held in 1966 at the Amon Carter Museum of Western Art, in Fort Worth, Texas.

Dasburg's work has changed inevitably and gone through periods of turbulence, but it is remarkably unified. He has reacted with intelligence and insight to the dynamics of art's evolution in this century and is a worthy descendant of two of the greatest artists of the last hundred years, Cézanne and Picasso. Still active at the age of ninety-two, Dasburg spends part of each day drawing in or near Taos, New Mexico, where he has lived for over half a century. French born, but American by virtue of his lifetime residence in this country, Dasburg has always tested himself against ideas and standards of European origin.[2]

Undaunted by physical weakness and early poverty, he became one of America's leading artists and a persuasively articulate teacher and advocate of modern trends in art, thanks to the sharpness of his mind and his attractiveness as a person. He has a marvelously acute eye for geometry and understands, as few Americans of his generation do, that form is content. In his late drawings, which are perhaps his greatest achievement, he has admirably succeeded in combining the world of the spirit with the world of Euclid and Einstein.

Dasburg was born in Paris on May 4, 1887, and it is to France that we must turn for the key to his development as an artist. His consistent growth over a long and productive life has been capped by truly outstanding work in the last thirty years, that is, the years after he reached the age of fifty. It is an indication of his

continuing high level of creativity that in 1976, at the age of eighty-nine, he was busy executing a complex six-plate color lithograph. In this typically Dasburg composition, arching limbs and leaning tree trunks frame a clump of adobe houses. The individual plates for this print are very lively and speak eloquently of his verve, as does the complete composition.

The influence of Paul Cézanne can still be detected in this late work despite the passage of sixty-six years since Dasburg's first encounter with the French master's work (fig. 1). Andrew Dasburg would be the first to say that his life as an artist can be divided neatly into two parts: before and after the day he encountered Cézanne's work in Paris in 1910. Until he discovered Cézanne, Dasburg was slowly finding his way as an artist under the guidance of provincial American mentors. Only a few months after seeing and absorbing the lessons of Cézanne, he had adjusted his style to conform to his hero's concepts of pictorial form and space. Like Picasso, who read in Cézanne's work the same message Dasburg did, the American painter felt that he could make Cézanne's art indelibly his own while retaining the master's sense of dynamism and feeling of mass and solidity. Dasburg has continued to make telling use of Cézanne's interlocking patterns of solid forms and lines that move contrapuntally into and across an ordered pictorial space.

Although both Dasburg and Cézanne were born in France, their lives were otherwise dissimilar. Cézanne was from a comfortably well-to-do family. Dasburg's father was employed by the French National Railroad in a modest capacity; he died in Paris when his son was only two years old. Dasburg's mother first took her fatherless child to the town that had been the ancestral home of the Dasburgs in earlier times—Nittel, Germany, on the Moselle River, across from Luxembourg and about sixty kilometers south of the hamlet of Dasburg. Even at an advanced age Dasburg could recollect a few incidents of his early childhood life in Nittel.

> I can recall the journeys of exploration taken about the neighborhood by me and my friend Fritz. One Sunday morning we walked over toward the railroad tracks which were up on an embankment far above us. In order to cross to the other side of the tracks, we found we had to walk through a long, dark tunnel. Bravely we did this. Coming out of the tunnel we heard a commotion above us. People were running up and down the tracks, pigs were squealing, there was unusual excitement. Groups of people were going into a small cottage nearby. Fritz and I followed. We found that an old woman of the village had been struck down by a train and killed as she was trying to get her pigs off of the tracks.[3]

2

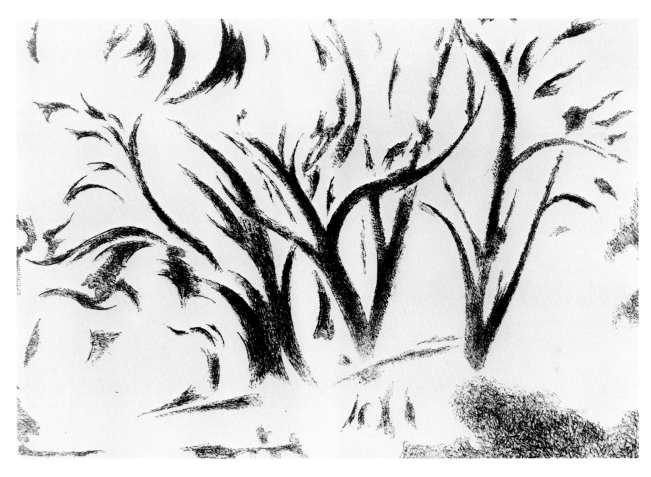

FIGURE 1. *Ranchitos Cadence.* 1975. Lithograph, 16½ x 23⅜ inches. Tamarind Collection, University of New Mexico Art Museum, Albuquerque, N.M.

This vivid memory stored in the mind of a four year old was only partially corrected many years later when Dasburg visited Nittel and found the embankment to be no more than four feet high and the awesome tunnel to have been a mere culvert. Regardless of the true proportions, his recollection of these topographical elements can be seen as a very early indication of his sensitivity to geometric forms in the landscape, a particular characteristic of his vision as a mature artist.

With little money and few prospects in Nittel, Dasburg's mother decided to come to New York City, where her sister, Angeline Caspar, and Angeline's husband, a marble polisher, lived. In 1892, the mother and young son made their way by steerage class from Holland to the immigrants' traditional gateway to

America. They moved in with the Caspars on West Thirty-eighth Street, in the neighborhood known as Hell's Kitchen. To support herself and her child, Mrs. Dasburg took work as a seamstress with a French dressmaker. Like other city children, Andrew played in the streets. While running one day, he fell into a street excavation and injured his hip. This hip, which it is now felt was probably tubercular, had been injured in an earlier fall in Nittel. The injury suffered in New York did not heal properly, causing young Dasburg to walk with a decided limp.

He started school at the age of six but could not keep up with his studies because he was often bedridden by his injury. In 1894, at the age of seven, he began to attend a special school for crippled children. Between 1894 and 1901, from the ages of seven to fourteen, he had to wear a metal hip and leg brace. With great fortitude he gradually learned to manage very well in spite of this handicap. At school he studied the usual courses for youngsters his age but was most excited by a manual training class where he learned to work with wood and metal, and to draw.

By 1902, he had so progressed in drawing that his teacher, Miss MacKenzie, took him to the nearby Art Students League and persuaded the school to accept him as a scholarship student.[4] He was fifteen when he began instruction in drawing from plaster casts of classic sculpture under the direction of the French-trained academician Kenyon Cox. In the 1880s, Cox had been a liberal force in American art, writing vigorously in defense of the nude in art for *Scribner's*, but by 1902 he was a somewhat bitter and uninspiring teacher. Dasburg remembers that Cox would pick up a student's charcoal stick, grunt, and then make a mark on a drawing in progress to correct a line, without explaining why he did so. This kind of instruction was not very helpful, and it ruined whatever had been achieved by the student in that particular drawing.

Despite having a limp, Dasburg walked the four long crosstown blocks from his new home on West Fifty-seventh Street to the League's quarters on the same street. This is a measure of the perseverance that characterized his attitude toward achieving any goal. Walking longer and longer distances, both as a form of recreation and as a means of strengtehning his hip, became a lifelong practice. His limp exerted both positive and negative influences on his life. He developed self-discipline to overcome his handicap, and probably his weakness made him more introspective than he would otherwise have been. Like Lord Byron's club foot, Dasburg's limp seemed to evoke from women of all ages a sympathetic response. This fact he well understood, and, consciously or unconsciously, he used it to capture the attention of women.

In 1904, Dasburg began instruction in painting in the life classes of Frank Vincent DuMond at the Art Students League. Claiming that all parts of the human body could be visually reduced to ovals, DuMond urged his students to become aware of the importance of formal geometric analysis when painting the figure. As a teacher, unfortunately, DuMond was too tied to nineteenth-century academic conventions to be very inspiring to a young man like Dasburg. The League, nevertheless, was a challenging experience. Writing in 1924, twenty years after Dasburg began his studies there, Allen Tucker, the painter and critic, characterized the spirit of the place: "The road to art was long and desperate, no one cared if he walked it or not, if he wanted to work the League held out every possible help, but it was entirely in the hands of the individual what use was made of that help. And a body of students grew up who really went to school to learn and for no other reason on earth, and they work as people work nowhere else, as men and women work for the sake of really knowing, with no certificate and no reward."[5]

More important than anything Dasburg experienced at the League, however, was the instruction in life and art that he received in night classes taken for three months at the Chase School under Robert Henri. Henri conveyed to his students, and to anyone else who would listen, the vital importance of art as a profession and a social force. His philosophy was to live intensely, to battle against tradition, and to consider every direction in art and life that led to truth. Henri's methods of painting were of no particular interest to Dasburg, but his crusading zeal was very inspiring for the young man. From Henri he absorbed a new vision of what it meant to be a venturesome artist. Henri was an enthusiastic proponent of everyday people and run-down parts of New York as subject matter. His paint-loaded brush defined the vigor of his mind as well as the path of his skilled hand. For an American artist he was advanced in both theory and practice, but in terms of international art and ideas he was just beginning to understand Manet.

In his teaching Henri emphasized the importance of a well-defined substructure, whatever the subject of a painting might be. This concept, while certainly not new, was challenging for Dasburg. Henri encouraged him to give more and more attention to establishing a clear sense of weight and mass for the forms in his pictures. This became one of Dasburg's major aims. He believes, as did the seventeenth-century philosopher Spinoza, that God proclaimed the logic of all things in the harmonies of nature. Like Einstein, whom he greatly admires, Dasburg feels that God created structures in nature in simple rather than complex formulas. These views shaped much of his art.

In 1906 Dasburg was awarded a landscape painting scholarship at the Art

Students League's newly established summer program in Woodstock, New York. The little town of Woodstock was to be Dasburg's home for part of each year from 1906 to 1928. This hamlet eighty miles north of New York City was originally a farming center, with some productive stone quarries nearby. Birge Harrison, an American landscape painter who had lived in France and was a member of the National Academy, came to the Woodstock area soon after the turn of the century to teach in an arts and crafts school established by Ralph Radcliffe Whitehead. He was just one of a number of artists who found the landscape and pace of life attractive. In 1906, when the Art Students League invited Harrison to teach landscape painting at their summer school in Old Lyme, New York, he suggested that they move the summer school to Woodstock. The move changed the complexion of the town at a critical time in its history. The introduction of cement and macadam as the principal paving materials for streets and curbs was fast killing off business at the local stone quarries, and the land was losing some of its agricultural productivity. With the coming of the League's summer school, barns became studios, houses in town and in the country took in boarders, and the stores in the village flourished as never before. At times two hundred art students spread out over the countryside to sketch under wide umbrellas. The area became an art colony with a pottery, a hand-crafted furniture shop, a press, a theater, and eventually a gallery. Scholarships drew a more serious group of students than had previously come to the summer art colonies; Dasburg was one of these. The students lived in a dormitory in Rock City, a mile north of Woodstock, or rented rooms in local houses. They attended classes in a converted livery stable near the Woodstock village green.

In 1907, Dasburg met a sculpture student at the League who impressed him greatly with her drive, artistic talent, and literary sophistication. Her name was Grace Mott Johnson—the first of the remarkable women with whom Dasburg was allied. Raised on a farm in Monsey, New York, she was the eldest of seven children. Her father, a Presbyterian minister, had cared for her from the time her mother died when Grace was two years old until he remarried, so there was a very close bond between father and daughter. After his second marriage Mr. Johnson left his congregation and secluded his family from a sinful world. None of the children attended public school, and they seldom went to the nearby town. Directed by their father, who had had a classical education, the children built a nature museum and produced articles and pictures for a periodical about all their activities; this was their education. Johnson (as Grace was usually called) illustrated the newspaper with drawings of animals. The results were unusually good, and she was

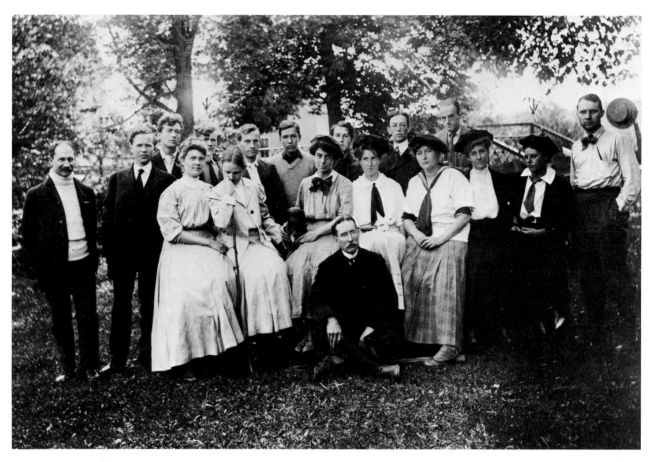

FIGURE 2. Birge Harrison's class, Woodstock, 1907. Dasburg is fourth from left; Grace Johnson is the woman at far right. Collection of Alfred Dasburg, Santa Fe, N.M.

encouraged to develop her skills. When she was twenty-one, however, she revolted against the restrictive life imposed by her father. At that time she received a modest inheritance from her maternal grandmother, left the farm on her bicycle, and made her way to New York City. She was studying at the Art Students League with the sculptor Gutzom Borglum when Dasburg met her. Her animal sculptures were outstanding and she soon gained considerable recognition in the United States and France in the years immediately before and after World War I. Dasburg, who was five years her junior, wanted to marry her soon after they became acquainted, but she was not ready for marriage. He even considered giving up painting and taking a regular job to support her, a plan Johnson vetoed in no uncertain terms. In early August, soon after making this suggestion, he wrote to her from Woodstock.

She was preparing to go to Europe at this time, staying at the home of her favorite relative, her Aunt Frances Johnson (her father's sister), in Yonkers, then just a small town north of New York City. Dasburg told her:

> The ride out from W. Hurley was very fine. I saw many things that made me reconsider my thoughts of the morning about giving up art. One thing that I especially wished you had seen with me was a man and two children husking corn. They were about half way up a bare hillside, husking corn from a large pile brought from the field on the other side where it grew. Another large stack of it was on top of the hill like a monument to the harvest. The people sitting amongst the scattered stalks and piles of golden ears gave charm to the landscape, which otherwise would have been cold. A stone wall, path, stump of a chopped tree, plowed field, any suggestion of man being or having been present, always makes a landscape, or should I say nature, more impressive, wondrous and mysterious to me. I feel just now that I never will be satisfied with just painting atmospheric conditions and changes of light, but if I can, to get a feeling of reverence for this great wonderful drama, of which I am one of the gropers. I wonder if it is possible to get it (the great drama of nature) just in the painting of a tree? Trees always do seem a great deal like people to me. Some have the characters of children, young men and maidens, old men, strong and healthy, others, battered by the storms, look like Rembrandt's head of the Jew who has stood many storms, looks at one with a sad melancholy, one who has felt the sorrows and joys, feels for humanity, carries his burden silent as a tree. My dear girl, I am afraid I will have you thinking me inconsistent again if I go off in such wild flights as these which I feel stronger than I seem to know how to express. I often hope you will encourage me to do it and will stand being made a target for my gushings, help and teach me to find and express myself. You have helped me a great deal more than you may perhaps ever realize. . . . I am certain I am not as cold as I appear to myself and others at times. It is due I think to the way I have had to harden myself.[6]

This warm, well-expressed letter is quite revealing, giving us an idea of Dasburg's responses to nature and his need for companionship. It clearly shows that he was attracted to Johnson in part because of her encouragement of him as an artist. She had taught her younger half-brothers and half-sisters while growing up on the farm.

Even though she spent much time and energy developing her talents as a sculptor, she played the role of teacher with Dasburg. The two spent a great deal of time together and went on walking tours in New York State with other art students.

Johnson was often in Yonkers, where she received letters from Dasburg almost daily. A 1908 letter gives an indication of how Dasburg spent his days at Woodstock and what he thought about as an artist.

> This is a fine clear cool and windy day, the kind that makes one feel like walking and work. I walked over the fields for two hours and could not find anything to enthuse me; I do not want to repeat the performance of this morning, that is why I am writing to you this afternoon. I will take my sketch box with me when I go out to supper and go out after the light is more interesting than it is during a sharp day like this. I hope there will be clouds in the east this evening. Yesterday I made a little cloud study which I think is better than any I made last year. Up to the present I have accomplished but very little work. I hope that soon I will be in line again. . . . I made a little decorative landscape composition with two little nudes in it. I will send it to you when I have a frame, with the intended one, for you to see or keep if you care for it. I may be able to make it good enough to sell, if I have an opportunity to sell it. I will let you see it, it is yours first. This almost sounds as though it were a fine thing, but it is not.[7]

In his letters Dasburg expressed his feelings about Woodstock as an environment, his teacher Harrison, and the type of paintings he was doing (see fig. 3). In a letter to Johnson dated November 16, 1908, he wrote:

> Today Woodstock is wearing her winter garb of white, given her last night by a fall of about four inches of snow. My eyes have not as yet gotten accustomed to its dazzling brightness. I am hoping that tomorrow will be a gray day, for the sunlight is too brilliant for me just now to paint. I suppose I will get accustomed to it in a day or two. Today I did not paint outdoors; this morning I finished a plowed field, a product of two days ago. Harrison does not think it is a picture, for which I am not altogether sorry. He showed us some of his work today which were strictly speaking *pictures*—to my mind, not very good ones. I think that you might like my plowed field; it has more character than most of my things. He advised me that I should look for things that were worthwhile

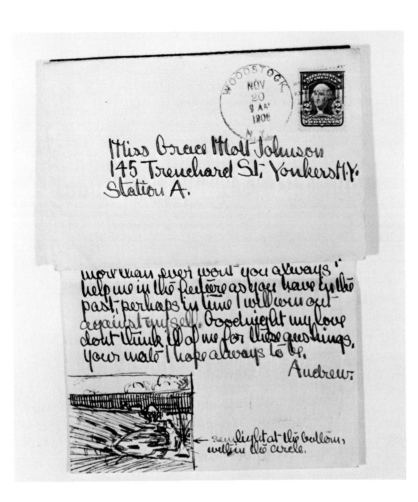

FIGURE 3. A typical Dasburg sketch in a 1908 letter to Johnson. Collection of Alfred Dasburg, Santa Fe, N.M.

painting; what I intend to do is to go outdoors and paint things that attract me, get the character of them in every color and light arrangement; perhaps in time something will evolve out of my work that is worthwhile.[8]

His energy, and his willingness to follow Harrison only so far, came out in this letter. Also evident were his misgivings about his achievements. It was Johnson's encouragement that helped him to persist as a painter. Dasburg liked Harrison as a man and found him gentle, sensitive, and versatile in his Saturday morning talks to the class when he reviewed what the students had done. As Dasburg became more confident as an artist, however, he felt a desire to strike out in directions not sanctioned by his teacher. Harrison was interested in night and twilight subjects, whereas Dasburg increasingly wanted to use bright colors as seen in full sunlight.

10

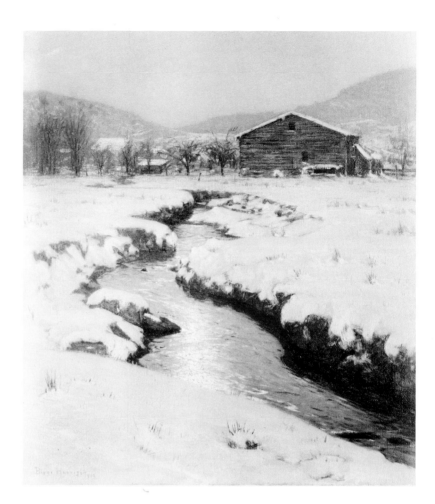

FIGURE 4. Birge Harrison, *Woodstock Meadows in Winter.* 1910. Oil on canvas, 46 x 40 inches. Collection of the Toledo Museum of Art, Toledo, Ohio. Gift of Cora Baird Lacey.

Harrison painted nature in its poetic aspects, with little concern for the advances in regard to color sensations and emphatic brushstrokes made a quarter of a century before by the Impressionists. The grays, browns, and purples that dominated his palette relate his work to the pantheistic painting of the Barbizon School of the 1840s. His romantic concept of landscape painting (see fig. 4) had brought him fame both in this country and in France, where he had developed his skill at evoking atmospheric effects that muted the reality of nature. He advocated that his students pay close attention to subtle tone separations and use subdued colors that caused forms to be less clearly defined. His misty paintings did not appeal to young Dasburg, who soon began to use reds, bright blues, and even orange. Because he went ahead and painted with these bright colors, despite Harrison's caution about their use, he became a leader among the students. In a rebellious mood, encouraged by one of the older students, James Wardwell, he

11

FIGURE 5. *Untitled* (landscape). C. 1908. Oil on canvas, 8¼ x 10¼ inches. Collection of Alfred Dasburg, Santa Fe, N.M.

organized the Sun Flower Club. The patches of bright colors that he and his followers used seemed raw, inartistic, and dissonant to adherents of Harrison's pearly tones. Harrison may not have liked what his student was doing, but he recognized that Dasburg was very talented, so he did not seriously attempt to stop him from going his own way. Many of the pictures Dasburg painted in Woodstock in the period 1906–8 were landscapes made up of broadly brushed passages that created a flat, tapestry effect (see fig. 5). That is, the individual elements were painted with the same kind of stroke, however detailed the forms may have been in

nature. The colors used were bright by Harrison's standards but to an Impressionist like Monet or Renoir would have looked quite somber.

Soon after he began studying at the League, Dasburg also met there the young sculptor and painter Charles Morgan Russell, who was making his living posing as a model for, among others, Gertrude Vanderbilt Whitney. Russell was able to go to Paris in 1905 when Mrs. Whitney agreed to give him a modest monthly allowance. During the summer of 1907 Russell, Dasburg, and Walter Dorvin Teague, who became a prominent industrial designer, rented a little house at Rock City, near Woodstock, for two dollars a month. There, Dasburg recalls, "We had a few chairs, some dishes and a cot each."[9] While Dasburg was slowly progressing in Woodstock, Russell, with the help of his money from Mrs. Whitney, went to Paris every year, finally settling there in 1909. He corresponded frequently with Dasburg, describing the art scene in France and urging his friend to return to the city of his birth to see the new directions art was taking there. He told Dasburg about Monet, Cézanne, Gauguin, and Matisse in his letters and on visits back to this country. In 1908, while on a visit to the United States, Russell joined Dasburg and Johnson, by then Dasburg's very frequent companion, on a walking and talking trip from Boston to New York City, staying in farmhouses along the way.

In early 1909 Dasburg spent two months in Boston. There he devoted a great deal of time to studying in the Boston Museum of Fine Arts Library the plates and reproductions of anatomy in the famous books on this subject by Gray and Rimmer. Despite being very short of cash he even bought some of the latter for further study. Though interested in anatomy, he was still challenged by the problem of making colors work together.

Russell's letters from Paris about the new things he was discovering there about color were very exciting for Dasburg. In one he said, "What one sees—is a multitude of tints grading and contrasting in an infinity of directions. One does not see 'solidity' and one does not paint 'solidity'; one paints chromatic lights. The solidity results if color is tensely organized. . . ."[10] This kind of thinking fascinated Dasburg, who by nature was also a theoretician.

Inspired by this kind of talk, in April 1909 Dasburg and Johnson sailed for France with their friend Florence Lucius. In Paris they were met by Arthur Lee and Morgan Russell, friends who were both working as sculptors at the time. They also saw in Paris another sculptor friend, Jo Davidson. Dasburg was very involved in ideas about sculpture as well as painting at this point in his career, which explains in part his interest in Johnson. After eight weeks in France, Dasburg and Johnson sailed across the English Channel in late June. They were married in early

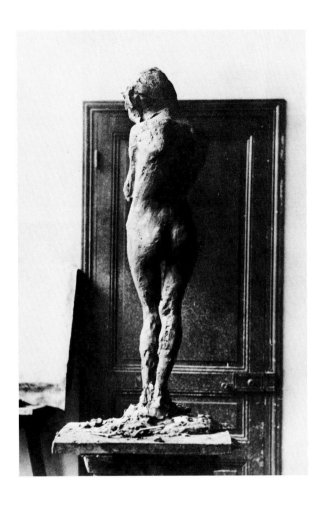

FIGURE 6. *Female Figure.* 1909–10. Lost. Photograph from the collection of Alfred Dasburg, Santa Fe, N.M.

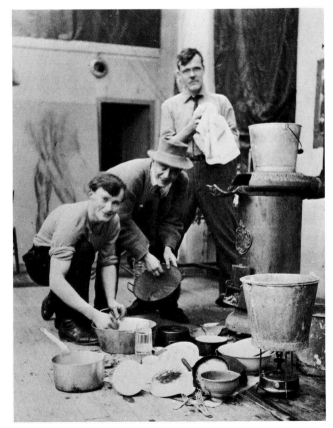

FIGURE 7. Dasburg (left), Arthur Lee (right), and an unidentified companion in Paris studio, c. 1910. Collection of Alfred Dasburg, Santa Fe, N.M.

July in a civil ceremony at the Registrar's Office, High Holborn and Tottenham Road, London, with Arthur Lee as witness. No traditional vows were exchanged, for Johnson wanted theirs to be a completely free alliance. They immediately returned to Paris, to the studio that had been established earlier on the rue Notre-Dame-des-Champs. In August and into September Dasburg was painting in Concarneau, in Gauguin's old Brittany Coast area. In January, Johnson became ill and returned to the United States. Dasburg stayed on in Paris for another six months.

Dasburg and Russell often worked from the same model. Michelangelo's sculpture was their inspiration. The way he had exaggerated the muscularity of his figures to give them a superhuman character appealed to both the young American artists. Russell had turned to painting and was working on large, brightly colored canvases in what eventually became identified as a Synchromist style. Dasburg, less concerned with the power of primary colors, concentrated on the arcing contours of the figure. Dasburg, as was to be the case with all of his work, was very interested in conveying a sense of mass. It is therefore not surprising to find that he tried his hand at sculpture while in Paris. None of his efforts have survived, which is unfortunate from the standpoint of a study of his ideas.

Matisse had been persuaded to conduct a class for a group of aspiring American artists, of whom Russell was one. As a result Dasburg was able to go with Russell to the master's studio and see him work. Dasburg vividly recalled the sight of Matisse painting the early version of a group of dancers. He would paint, then erase with a cloth and benzine what he had just done, then paint again and erase again for over an hour until he finally achieved the feeling of spontaneity he wanted in a dancer's flexing shoulder. Dasburg noted that Matisse's line "had limpidity and casualness without being forced at all."[11] This experience gave the young visitor from America an indelible lesson in how to invest form with the vitality of life itself without resorting to details.

From the earliest days of his visit, Dasburg spent a good deal of time roaming the streets of Paris—he frequently walked five to ten miles a day to accustom himself to the gnawing effect of the pain in his leg and to strengthen his muscles. One day, on a long walk, he discovered in a shop window some paintings that fascinated him. Here is Dasburg's own account of the experience that most shaped the direction his art was to take:

> I came upon a small gallery where, in the window, were three or four paintings by Cézanne, whose name I had heard mentioned but knew nothing of. I looked at the signature. I was immediately impressed by the great plastic reality of the paintings. I looked through the door and a

dark bearded gentleman asked me to come in. The gallery was hung with Cézannes. I looked for a long time. The gentleman saw my interest and invited me to a back room where many paintings by Cézanne were kept. I was completely imbued with what I saw—one of those things that rarely come to one but when they do, they are forever memorable.[12]

When he returned home that day he told his friends the story. They told him the person he had met was Ambrose Vollard, the shrewd dealer who had handled Cézanne's paintings for years while the artist was still alive and before he had become famous.

While in Paris, Dasburg was also impressed by the work of Renoir. He saw wall panels and canvases by this master hung floor to ceiling all over the home of the famous dealer Durand-Ruel. These works and others he saw by the Impressionists gave Dasburg a perspective on how a once innovative movement could become conservative with acceptance.

To further his education, Arthur Lee took Dasburg to the rue de Fleurus to meet Leo and Gertrude Stein, who had regular days when they entertained American artists and showed them their remarkable collection of early work by Matisse and Picasso as well as examples of Cézanne's paintings.

On one visit to the Steins' place Leo loaned Russell and Dasburg a small Cézanne still-life panel of five apples to be studied and copied. Dasburg was especially interested in determining how Cézanne achieved his sense of mass in the seemingly simple composition. He copied it many times while it was in their possession. All these copies have apparently been lost, although one can be seen in a photograph, hanging on the wall of Dasburg's Paris studio.

On April 24, 1910, Dasburg wrote to Johnson about what he was doing and explained what this meant to him:

> Yesterday and the day before I have been making a copy of a small Cézanne that belongs to Mr. Stein. Have two copies that are much better than I expected to get. I may give one to you if I find that in one of them I will have enough of what I copied it for. To me the original is infinitive. It will rest in my mind as a standard of what I want to attain in my painting, i.e., the qualities which it contains to such a great degree.[13]

After another trip to Brittany, painting around Concarneau, and a tour along the Rhine to Holland in July 1910, Dasburg sailed for New York in August on the S.S. *Rotterdam.*

When Dasburg returned to the United States in August 1910 he went up to

Woodstock to live and work. He helped his mother and her sister buy a house in Wurtsboro, New York, and spent the fall repairing it. For the next two years he spent much of his time in Woodstock, though because Johnson maintained a studio in New York City with her friend Lila Wheelock he was frequently in the city. In May 1911 Dasburg's only child, Alfred, was born in Yonkers. The care of the child was divided between the parents, Dasburg taking him for as much as six months each year to permit Johnson to work at her sculpture. During the summers of 1911 and 1912 Dasburg taught painting at Woodstock. In the fall of 1912 Johnson inherited enough money to buy a house and considerable acreage at Woodstock for thirty-five hundred dollars.

Dasburg was painting at this time but his interest in sculpture continued. In the spring of 1912, Alfred Stieglitz showed nine pieces of Matisse's sculpture and a group of drawings at 291. Officially known as the Photo-Secession Gallery, this little art and photography gallery, generally referred to simply by the number, was located on the top floor of a brownstone at 291 Fifth Avenue. Here Stieglitz exhibited the work of avant-garde artists, mostly European but including a few innovative Americans. Stieglitz sponsored some of what were called the craziest painters in America—John Marin and Abraham Walkowitz, Arthur Dove and Marsden Hartley—and thereby gave others, like Andrew Dasburg, the courage to paint things as they wished to.

The 1912 Matisse show at 291, the first exhibition of Matisse's sculpture presented by any gallery, included an innovative piece called *La Serpentine*. In this frontal-oriented sculpture Matisse had used a very slender figure to display the same arcing forms that Russell and Dasburg had experimented with under the influence of Michelangelo's heroic figures. Writing to Johnson, who was in Woodstock, Dasburg said of Matisse's plastic responses to the models:

> Even I was a little startled and amused at first. There are several portrait heads and a figure that will haunt the minds of N.Y. sculptors for some time to come. They will create nothing less than a sensation.[14]

In a letter to his wife about *La Serpentine,* which he facetiously called "Lady Macoroni" [sic] he said it was "startling at first but beautiful after one comprehends the design."[15] His sketch in the letter (fig. 8) had been drawn from memory. When he returned to see the Matisse show a second time, he found his recollection of the details had been in error, so he wrote instructing his wife to correct the sketch: "The actions should be reversed and her leg crossed in front of the leg she stands on instead of in back."[16] Dasburg's interest in sculpture

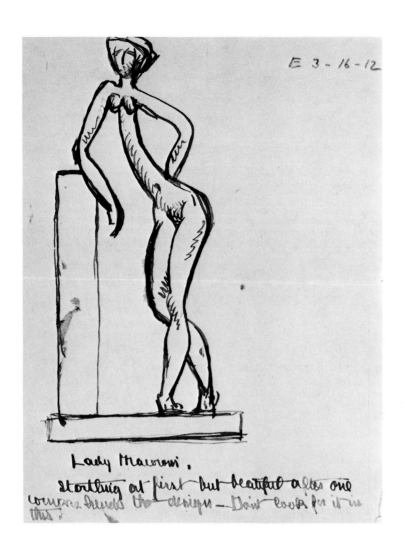

E 3 - 16 - 12

Lady Macoroni,
Startling at first but beautiful after one
compare here the design — Don't look for it in
this .

FIGURE 8. *Lady Macoroni* [*sic*], sketch from memory of Matisse's *La Serpentine*. 1912. Ink. Photograph from the collection of Alfred Dasburg, Santa Fe, N.M.

continued, at least to the extent of inspiring him in 1912 to remake in a modified Cubist fashion a head he found abandoned in his friend Arthur Lee's studio. Titled *Lucifer*, it was to be for a time one of his most innovative works.[17]

The stimuli bombarding Dasburg at this time led him to new intellectual formulations that he was eager to spread among his colleagues. Having discovered Cézanne and Cubism, he understood at once how together they could serve as the model for the future development of his art—and modern art in general. He was excited about his new knowledge for himself, but he also wanted others to understand the significance of Cézanne's and Picasso's achievements. "I came back from Europe inflamed like a newly converted evangelist," he has written. "I talked

18

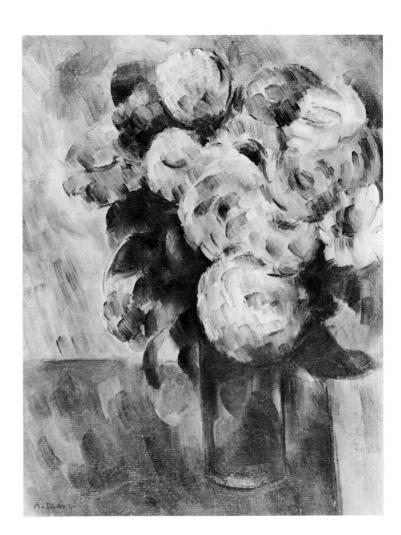

FIGURE 9. *Untitled* (still life). C. 1911. Oil on canvas, 16¼ x 13 inches. Collection of Alfred Dasburg, Santa Fe, N.M.

endlessly about what I had seen and found a good many sympathetic listeners, some of whom became converts."[18] To students in Woodstock and to his many friends in New York he explained that Cubism offered American artists a means of breaking away from what he considered to be outmoded ideas about form and color.

Sometime in 1911 or 1912 Dasburg painted a still life of a bouquet of flowers in a simple, round container (fig. 9). While this early painting occupies a peripheral place in Dasburg's life work, it does indicate how both Renoir and Cézanne influenced his style. There is a debt to Renoir in the way the subject is seen in relation to light, and in the verve of the paint handling. The paint was applied in

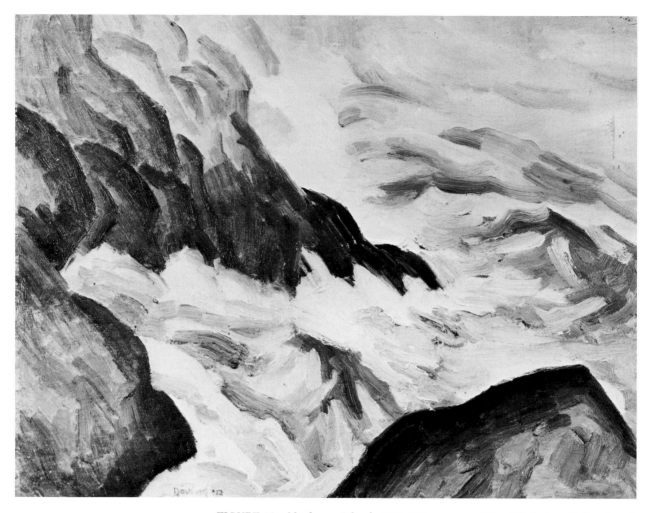

FIGURE 10. *Monhegan Island.* 1912. Oil on canvas, 15 x 19½ inches. Collection of Alfred Dasburg, Santa Fe, N.M.

loaded strokes, pulled across the surface a half-inch or so, then released to meld into the next block of pigment. This sounds like a description of a detail from a Cézanne painting. The difference is that the edges of the little passages of paint are not emphatically defined as in a Cézanne, and the five or six soft blossoms tend to vibrate as they flow one into the other. It is the spontaneity of Renoir's brushstrokes that is evoked, as is his delight with bright colors. The picture is of interest today primarily because the generalized handling of all the elements shows evidence of Dasburg's new breadth of vision after his stay in Paris.

20

In the summer of 1912 Dasburg spent a month on Monhegan Island, off the coast of Maine. The sixteen small paintings he did there were marked by a forceful application of paint that would have made his early teacher Robert Henri happy (see fig. 10). Dasburg loaded his brush with thick paint and handled it like a sword; a kind of cut-and-thrust application of pigment was the result. The summary quality of a sketch was appropriate for his appealing pictures of the rugged rocks along the coast, against which the sea surged and turbulent waves broke. On this trip Dasburg painted alongside his friend George Bellows. Bellows's work was also vigorous and, like Dasburg's, reflected the advice of their mutual teacher, Henri, to paint with verve to get the sense of a subject. Even though they had followed their teacher's dictates, however, the work of both lively-minded young painters was relatively timid by European standards, which reminds us how limited was the compass of American art at the time. There was a feeling, however, that changes were needed.

In 1912, in a spirit of innovation, a progressive group of artists in New York, dissatisfied with the conservative National Academy, formed a new organization called the Association of American Painters and Sculptors. The secretary was Walt Kuhn, and among the organizers was Dasburg's friend the sculptor Jo Davidson. The group set out to hold an international exhibition of what they broadly considered to be modern art. Kuhn went to Europe to secure the loan of work of nonacademic artists in Germany and France. Upon his return, while he and Jo Davidson were in New York, they encountered Dasburg, told him of the progress they were making on the exhibition, and asked him to bring some of his work for inclusion in the International Exhibition of Modern Art. At the time he was spending a good deal of time in New York and welcomed the invitation. Sales had been few, but his life was satisfying, for with Max Weber and Eugene Speicher he was teaching a class at the League in which each artist took the students for one-third of the winter term. After considerable thought and discussion with Johnson and others, Dasburg decided to show not only paintings in the international exhibition but a piece of sculpture as well.

Three of Dasburg's paintings and one sculpture, *Lucifer* (see fig. 11), were exhibited in the Armory Show, as this exhibition of over 1,600 examples of modern art has come to be called. Dasburg's paintings were two still lifes in oil priced at $250 each and a landscape in oil at $350. They were hung at eye level in a good location. All had Cézanne characteristics. The sculpture was the life-size plaster head by Arthur Lee that Dasburg had extensively reworked by the unusual procedure of carving into the plaster. Johnson was invited by Arthur B. Davies, one of the most important organizers of the exhibition, to show her sculpture in the huge show, so she and Dasburg were each represented by four works.

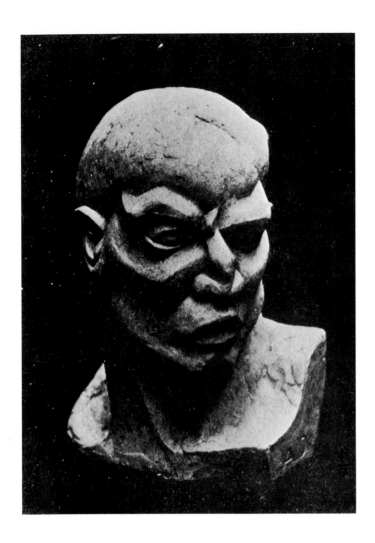

FIGURE 11. *Lucifer.* 1912. Plaster. Official Armory Show postcard. Original destroyed.

With great fanfare the Armory Show opened in February 1913 in the Sixty-ninth Regiment Armory in New York. Dasburg thought the American section dull but was terribly excited by the paintings of his early heroes, Cézanne, Picasso, and Matisse. His own work was hung near Marcel Duchamp's soon-to-be-famous *Nude Descending a Staircase.* Dasburg was fascinated by the Cubist-Futurist painting. Eventually he came to know Duchamp quite well over games of chess and in talks at 291, when the French painter came to New York in 1915.

While Dasburg found the Armory Show very stimulating, his former Art Students League teacher Kenyon Cox expressed dismay and disapproval of much that was included in the international portion of the exhibition. On the other hand, Mabel Dodge, who later became Dasburg's patron and close friend and was at this time only a few months back in the country after living in Florence and Paris,

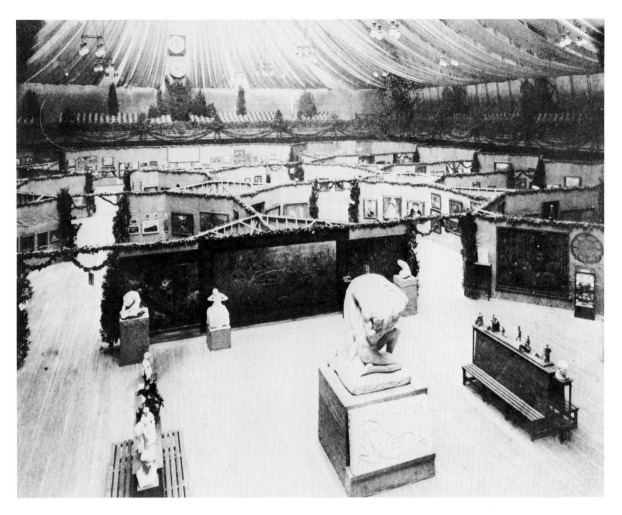

FIGURE 12. The Armory Show, New York, 1913. Note Dasburg's bust *Lucifer* in lower right corner. Photograph courtesy of the Smithsonian Institution, Washington, D.C.

wrote an exuberant, very affirmative review of this extraordinary exhibition, which ran until March 15, 1913. The Armory Show had a very stimulating effect on Dasburg and a number of other American artists. Although he had seen some of Picasso's and Matisse's work in Paris, he had no idea before the Armory Show how far-ranging was the influence in Europe of these artists' ideas. The challenge of differentiating between innovators and followers in the exhibition sharpened his eyes.

After the Armory Show there was a good deal of talk in Woodstock between Dasburg and his friend Konrad Cramer about abstraction as an aim in art. They

FIGURE 13. Dasburg and Konrad Cramer, Woodstock, New York, c. 1913. Courtesy of Alfred Dasburg, Santa Fe, N.M.

FIGURE 14. Konrad Cramer, *Untitled* (abstract). 1912. Oil on panel, 21 x 16¾ inches. Private collection, Los Angeles, Calif., photograph by John D. Schiff, New York, N.Y.

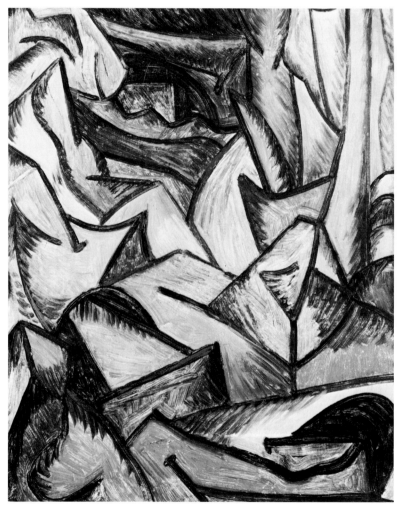

were both interested in breaking away from what the eye saw as reality and testing the effect of abstract pictures on beholders. Cramer had come to the United States in 1911 from his native Germany, where he had studied with the innovative Expressionist Schmidt-Rotluff. He also was well aware of Cubism. To him the Armory Show was more of an affirmation of avant-garde ideas than the startling revelation it was to American artists.

In Munich Cramer had become acquainted in 1910 with the Expressionism of the *Blaue Reiter* group. As a consequence he was the most innovative of all the Woodstock artists of that time. Before coming to America he had been exposed to both Kandinsky's and Marc's bold, simplified work, which was fast approaching abstraction by 1910. Problem oriented, Cramer gradually developed a painting style that involved bright colors, vigorously applied in broad but lean sweeps of the brush (see fig. 14). The strokes were very directional, as in a late Cézanne. Passages were made into flickering forms, as in a fire, by short, dark lines that were not directly connected but had an arabesque rhythm overall.

On one occasion in Woodstock Cramer showed Dasburg some color charts and suggested that these devices could provide the basis for a purely abstract art. In a letter of Dasburg's to Johnson, written on October 5, 1913, there may be clues to the origins of his earliest abstractions. He wrote:

> After lunch I intended to return [to his studio] and continue with a still life that I started this morning but Konrad became interested in color charts and chromatic scales, complimentaries, etc., which led to a discussion, then more arrangements until late in the afternoon. I finally evolved an order of complimentaries based on the triangle which is satisfying and has possibilities for further experiments. The number 3 seems magical. I believe it always has had a sort of mystical significance. Any order that is based on it and perhaps 7 is satisfying aesthetically to me.[19]

By the end of the fall of 1913 Dasburg and Cramer were both painting pictures that were close to pure abstraction, titling them *Improvisation*. Dasburg has said that as early as 1912 he conceived of a painting "that could exist as a thing in itself without reference to a subject beyond its general color and configuration of movement, allowing the form to evolve out of these two primary elements."[20] From what is known of his 1912 work, it would seem that his recollection in 1957 about these early years was somewhat faulty. His first abstract or nearly abstract paintings postdate the Armory Show; they were probably painted during the fall of 1913.

In the fall of 1913 Dasburg was painting in Woodstock with his friend Lee Simonson while Johnson was in Yonkers. From a letter he wrote her in October 1913, we can see how clear Dasburg's critical eye was when it came to basic values. Writing about Arthur B. Davies, he was able to see what every critic today would regard as obvious—that Davies was of interest merely as an example of an American borrowing the superficial aspects of a master's work. Dasburg wrote:

> Teague thinks that Davies' is about the finest show he's ever seen and thinks that he has done everything the modern Frenchmen and Cézanne aimed to do. I differ with him in this altogether. Davies' art to me is not vital enough to command such praise. To me he is a maker of fairy pictures; their dominant interest is literary, illustrative of a world of his fancy, rich in imagery and stated with fair color and often charming design. The strangeness of the illusions depicted, I think, is mistaken by many for aestheticism. It is not the intensification or exaggeration, if you care to call it so, that springs from a strong impulse of an aesthetic quality but to me is the result of an emotion that is dominantly objective. I do not say that they haven't charm but that his art is not a living force and therefore he cannot be ranked among the great men of all time where Teague places him. To say that he embodies Cézanne means that one has only seen the unimportant side of Cézanne. To tell the truth I think his art is weak, decadent, for it does not start from life but gets its inspiration from the sentimental aspect of other arts.

Dasburg goes on to say, "To me Cezanne is sublime, each contact with his art fills me with new life so to say, whereas Davies but amuses for a time."[21]

Another letter to Johnson, written from Woodstock in October, gives us an index of Dasburg's thoughts at the time and displays his deep love of nature in its largest and smallest manifestations. It also indicated that he was still painting some pictures from nature.

> It was enervating and ready to rain any moment. But it did not, perhaps for fear of disturbing the stillness. One heard every sound in the village, the air seemed so empty of its own sound. Haven't you seen days like this? When the clouds are few and the atmosphere heavy and blue thru which all the sounds below in the valley rise with greater clearness because of a stillness that seems strange and unreal, a stillness that one remains conscious of, and that is full of the noises of barking dogs,

crowing roosters, children calling to one another and all the sounds that are in a day's work and play. The autumn foliage looked glowing thru the blue haze. I particularly like the hill in back with its dark bushes of laurel among the red sumac and gay maples and sweet fern, yellow grapeleaves, hazel bushes in blossom that smell so like the fallen leaves after a rain. There are some late roses on the pink rambler and your flowers begin to look like white stars among the purple morning glories. I gathered some chestnuts for you before breakfast. Beautiful here now tho the trees are not so brilliant as we have seen them other years. I think of you as you are one of the rare few who appreciate nature in detail and in mass. I thought of you this afternoon when I was kicking Simonson in my mind for being oblivious to everything but his hat and pipe and cursing America for its not being French country. It made me wish for someone like you to talk to who could enter into one's appreciation of those things that are such a wealth of beauty to him who can see the wonder in the forms and colors of leaves and flowers when not looking at the hills or distances. The Japanese and Chinese artists had a great love for nature intimately and at a distance. Simonson came over to paint the yellow flowers you got at Birdcliffe. They interested him mainly I think because of their resemblance in color to one of his neckties. I have no reason to assume this other than my knowledge of his great delight in colors that resemble those in his necktie collection.

I nearly completed my still life today and now am ready to start a canvas of the mountain and in several others pursue "the thing in itself."[22]

Dasburg came to New York City in November 1913 for the opening of an exhibition at the Macdowell Club in which he showed some of his recent abstract work. The paintings that he exhibited have been lost, but from reproductions and critical comments we can get an idea of what they looked like. They were almost abstract, distinctly different from the paintings he had exhibited that spring at the Armory Show. They had overlapping planes of stepped arches spread about the canvas as if exploded, with great attention paid to the rhythms of the various shapes. He combined elements from Kandinsky and Cubism, with the former dominating. The Kandinsky quality may have been derived from Dasburg's study of the Russian painter's 1912 picture, *Improvisation No. 27*, in the Armory Show or from Cramer's abstract work.

Among the people Dasburg met at the Macdowell Club show were John Reed, the young radical journalist, who at the time was living with Mabel Dodge, and Robert Edmund Jones, a young stage designer who was a very close friend of Mabel and had been a classmate of Reed at Harvard. Soon after Reed met Mabel and began living with her in 1913, he had encouraged her to involve herself with a workers' strike in a silk factory in Paterson, New Jersey, and in other leftist activities. Her interest in radical politics was an extension of her interest in all that was exciting. Jones and Reed invited Dasburg to attend one of Mabel's Thursday evening gatherings. She was informed of the invitation and soon thereafter sent a written invitation to Dasburg and Johnson to join her during a gathering in December. Although Dasburg says that at this time he had never met Mabel, her memoirs state that she had seen "a good deal" of him before this December party, having met him at 291.[23] Evidence seems to indicate that her recollections were faulty.

Mabel Dodge's "Evenings" were modeled on the salons of Europe. When she and her wealthy architect husband, Edwin Dodge, had lived in Italy, they had had a salon frequented by prominent literary and artistic people. Feeling that her only child, John Evans, her son by her first husband, should have an American education, Mabel had returned to New York and eventually instituted her Evenings, for, as she said, "I wanted to try to loosen up thought by means of speech, to get at the truth at the bottom of people and let it out, so that there would be more understanding."[24] Although she rarely entered into the discussions, preferring to talk to one person at a time, she was very excited about being the catalyst for controversial and intellectually stimulating conversations. There gathered a group that at any given time could include socialists, trade unionists, anarchists, suffragists, poets, lawyers, psychoanalysts, artists, clergymen, and writers. A free exchange of ideas and opinions took place under the influence of good food and drink.

The first time Dasburg attended one of Mabel's Evenings (probably December 11, 1913), he found neither his hostess nor Reed present in the celebrated second-floor apartment at 23 Fifth Avenue. Reed had left for El Paso, Texas, early in December; he was preparing to go into northern Mexico to meet Pancho Villa, the revolutionary leader, and write a series of articles for the New York *Metropolitan* about him. Mabel, fearing she would lose her lover, followed him first to Chicago and then to El Paso, where she intended to wait for his return from Mexico. In New York, Mabel's close friends Lincoln Steffens and Hutchins Hapgood carried on with the Thursday Evenings during her absence.

Dasburg was very sorry to discover that Mabel had gone to El Paso, for he was anxious to meet her, having heard so much about her from Reed and others. Marsden Hartley later described in a letter his observations of Dasburg's reactions to the discovery that Mabel was not present. "I could see Dasburg was quite troubled and asked me secretly where Mabel Dodge was. I replied 'in Texas.' Dasburg was evidently wholly amazed inside—evidently disappointed with her absence—so much that he threatened to go home. I insisted that he remain and stick the evening out. . . . but it gave him one of those definite inner shocks which we all, as sensitives of one type or another, understand well."[25] Dasburg left the apartment with Jones. In the spirit of the pranks members of that circle often played on each other, Jones suggested that Dasburg retitle one of his new abstract pictures from the Improvisation series *The Absence of Mabel Dodge* and hang it in her living room for her to discover, like a calling card, when she returned from El Paso. This he did. The picture he chose for this new title was one of those he had painted when the Macdowell Club Exhibition was arranged.

Upon her return to New York in January 1914, Mabel found *The Absence of Mabel Dodge* on the wall of her apartment. Her impressionistic description of the work is helpful as an indication of how the forms and colors had been used in this now lost painting. "It was all a flare of thin flames with forked lightnings in them and across the bottom of this holocaust, three narrow black, black, black bars."[26]

It should be recalled that Mabel was a romantic person and, although an admirer of Gertrude Stein and her verbal "staccato portraits," had no adequate vocabulary to describe what was probably an almost abstract painting. She was very touched by this homage and obviously pleased by the romantic sentiments she seemed to have evoked in Dasburg. Her lover was riding troop trains in Mexico and showed no signs of hurrying back to her; she was ripe for another encounter with a talented young man and began to see Dasburg every day. "He was suffering," she said, "with a conflict of some kind." If this were not enough to attract her, the young artist was also strikingly handsome:

> He was so angelic-looking that it was hard to believe the flesh of him could feel what other people endured. His eyes were blue as sapphires, and they had a mystical red spark in them. His skin was so fair with a tremulous rose that came and went in his cheeks, and his fine blond hair rushed electrically back from his round brow and seemed full of white sparks of light. He had a frosty glistening light over him, and at the same time a warmer fire ran in and out of his blood. He limped a little and

always walked with a cane. His body was strong and light—broad at the shoulders with narrow hips.

Dasburg's proximity was exciting. In her characteristic style she wrote:

> As a flame darts out of itself and penetrates another element to destroy it or itself be quenched, so Andrew flickered out to me despite his own desire to be loyal to Reed. I encouraged Andrew because I wanted to be warmed by him; it was comforting. Sometimes I felt sorry that I had become attached to Reed, for Andrew had more weight and significance than the boy that Reed would always be. I felt: here is one I shall always be fond of no matter what happens. . . .[27]

She agreed to sit for a portrait by Dasburg to be titled *The Presence of Mabel Dodge*, now lost. (It may be one of the abstract pictures later titled *To Mabel Dodge* which have also been lost.) Mabel described this portrait, compared to *Absence*, as "a quiet blaze showing a red tulip in its center, and somewhere the emerald stone of the ring I wore."[28]

Mabel was especially entranced by *The Absence of Mabel Dodge* as a symbol of her reputation. Possibly to make Reed jealous, she asked Marsden Hartley to write a description of the picture so that she could acquaint Reed with it. Hartley wrote: "To describe it is difficult. It is full of the lightning of disappointment. It is a pictured sensation of spiritual outrage—disappointment carried away beyond mediocre despair. It is a fiery lamentation of something lost in a moment—a moment of joy with the joy sucked out of it—leaving the flames of the sensation to consume themselves."[29] This rather gossipy description of the painting, while decidedly overdrawn as far as the sense of "spiritual outrage" goes, does convey some of the effects on Hartley, another venturesome artist, of the colors and forms used by Dasburg in his first abstract or near abstract paintings.

Dasburg's natural charm and ability to convey his strongly held and very positive views about modern art soon made him a welcome member of the group who gathered regularly for Mabel's Thursday Evenings. Mabel was also attracted, as were so many women, by the élan with which the handsome Dasburg had overcome his physical handicap. A few letters from Dasburg to Mabel have survived that can be read as love letters. The nature of Dasburg's declaration in one case would seem to indicate he was waiting for her to accept him as a lover and that he recognized her strength and what he felt was his subservient role.

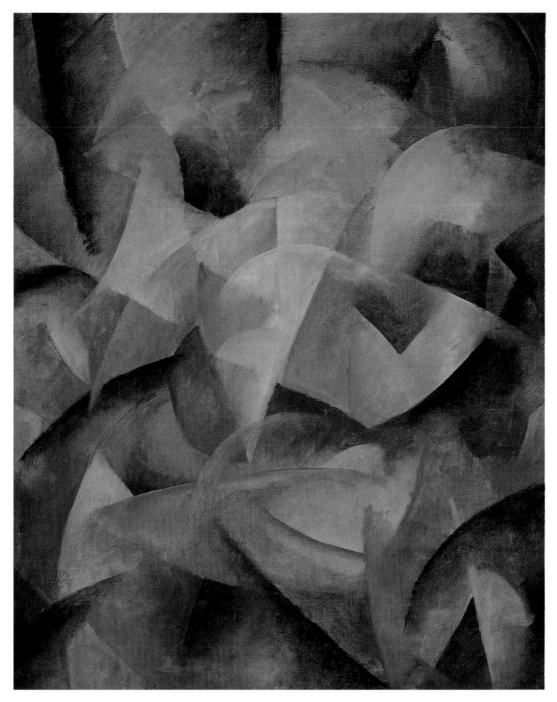

PLATE 1. *Improvisation.* C. 1915–16. Oil on canvas, 35½ x 29½ inches. Collection of Mr. and Mrs. Henry Reed, Montclair, N.J.

PLATE 2. *Sermon on the Mount.* C. 1915. Watercolor on paper, 12 x 9½ inches. Collection of the Roswell Museum and Art Center, Roswell, N.M.

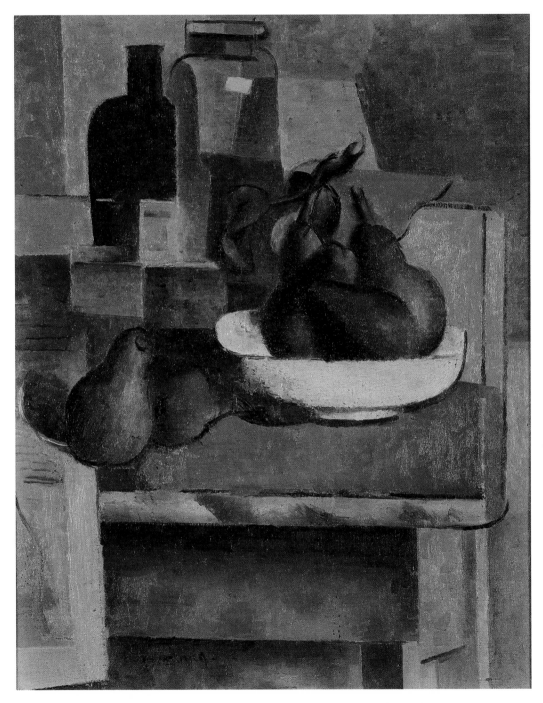

PLATE 3. *Still Life*. 1918. Oil on canvas, 16 x 13 inches. Collection of Mrs. Oscar Howard, Westport, Conn.

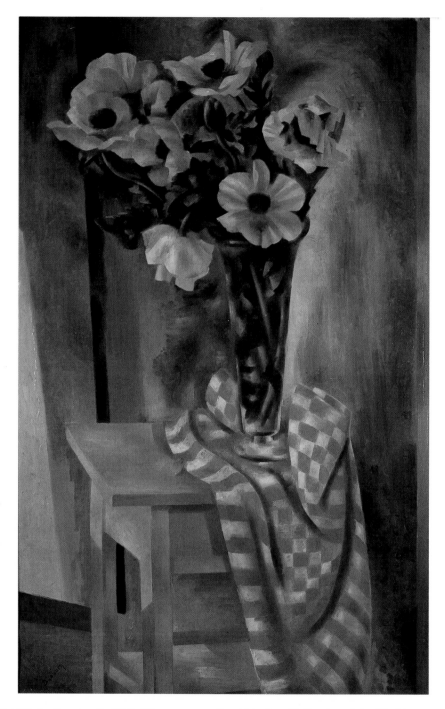

PLATE 4. *Poppies.* C. 1923. Oil on canvas, 40 x 26 inches. Collection of the Hirshhorn Museum and Sculpture Garden, Smithsonian Institution, Washington, D.C., photograph by John Tennant.

Dear Mabel—

"Paint" came as a blessing. It is the easier way. There is but one thought—the others would be thoughtful thinking to carry the message. In my chaos there is a dancing star. I want to say it with red ink, *I love you*. It crowds my head and suspends me trembling, like an aspen in the wind and impersonal, this is what is strange and a contradiction. I'm resigned to the role of the fluttering leaf waiting for the strong wind that will blow me to earth to you as a lover and not this trembling angel with cold hands bobbing in the clouds for warmth. Last night continued thru the night with you in a waking sleep.[30]

Mabel said, "His personality became interwoven with mine." On one occasion he wrote her a love letter and then called her on the telephone to say he couldn't bear the pain of being in love with her and not being able truly to express this love in physical terms. She replied that he should put it all in his paintings. In reply he wrote, "If my note of yesterday is madness, it is because I am mad. You tumbled me to earth beautifully. . . ."[31]

Dasburg soon had a room reserved for him in Mabel's apartment so he could stay overnight on visits to New York from Woodstock.

In late 1913, Marsden Hartley had just returned from Europe, and Mabel became one of his champions. After his show at 291 in January and February 1914 she arranged for his semiabstract work to be shown privately in her native Buffalo later in the year. The hostess for the Hartley show was Mabel's friend Nina Bull (Mrs. Henry Bull), a member of a very wealthy Buffalo family. The Hartley paintings were displayed in a large children's playroom in the Bulls' new mansion. Many friends of this family came to see the pictures. Dasburg had accompanied Hartley and Mabel to Buffalo. A rather philosophical letter to Johnson gives us an insight into Dasburg the natural teacher and his reactions to the smug visitors to the show of Hartley's work.

I have been trying to explain some Hartley pictures to the elite of Buffalo and believe me it is like trying to convert a Methodist into a Buddhist. All gods to them are of stone but theirs—if all of us are the grown-up children of habit, these or more truthfully some of these are the products of mediocrity. They are in the strait jackets of popular opinion and their spirits are shocked in their infancy and so are they now like the wax flower to the rose.[32]

In another letter to Johnson he wrote, "No one that I met had any immediate connection with the pictures, some were sympathetic and the others tried to appear not too old-fashioned. One might say that some were embarrassed as these things are so different that there is nothing that they could say."[33]

Dasburg conveyed a candid view of Hartley as a person in the same letter:

> I have been asked to finish out the stay with Hartley. He stays until the finish of his exhibit. If it had not been for Mabel Dodge and myself he would have been hopelessly stranded with his pictures as he has no sense of organization when it comes to arranging and getting things done. His is the true artistic temperament. If there is any such thing anywhere, he represents it. Paint he can and cook but nothing else. This is Hartley.[34]

After their return from showing the Hartley paintings Dasburg provided Mabel with the constant attention she needed to feel alive. As she described their friendship:

> I turned more and more to Andrew, and I lived in the electric atmosphere that surrounded him. Sometimes he seemed to flame like a star and sparks ran off the breezy hair that aureoled his round head. His body so slim, so broad and strong, as an organic thing full of terrible forces can be. I feel the wonder of life in him, tempestuous, rising like sap. There was a heady fascination in his vivid personality—eyes shining like sapphires turning suddenly black, and the quick rise and fall of color in his cheeks. His vitality swept him off his feet sometimes, until he seemed like a young tree bending in a great wind.[35]

When they returned to New York, Dasburg spent many evenings in Mabel's company, some with only a few people and others with a large number of guests. Mabel and her friends were always interested in new experiences, especially those that were related to mysticism or the forces of nature. In 1914 she and a small group of friends including Dasburg and Raymond Harrington, an anthropologist, experimented with peyote one evening. The results were disastrous for one guest, who became completely unhinged, experiencing a feeling of levitation and disconnectedness. At one point Dasburg said half to himself, "I saw what Sex is. It is a square crystal cube, transparent and colorless; and at the same time I saw that I was looking at my Soul."[36] This was one of the few instances when Mabel was carried away by her friends' venturesomeness. Usually she was supportive but essentially conservative in her behavior.

In 1914, the year following the Armory Show, another landmark exhibition took place in New York in February and March. Smaller than the Armory Show and restricted to American art, "Contemporary Art" was held at the National Arts Club. Dasburg was represented by *Lucifer*, a *Still Life*, and three paintings dedicated to Mabel Dodge—*The Absence of Mabel Dodge, To Mabel Dodge No. 1*, and *To Mabel Dodge No. 2*. The titles caused one commentator to see in the series "the vaporings of a calf-infatuation." Another reviewer saw them as "strenuous assaults on the optic nerves." In the *New York World, Mabel Dodge No. 2* was reproduced reversed and inverted as a complex of four images with a question mark in the center to indicate it did not make any difference which way it hung (see fig. 15). The reviewer for the *World*, with tongue in cheek, saw the picture as a symbol of "the unfolding of the torso and the exposure of the artist's heart in blossom as a tulip, with an amethyst shining in place of the navel."[37] It was very difficult at that time for even experienced critics to comment intelligently about works as close to abstraction as this painting, in which a blossomlike form was at the center and other forms reverberated out from the core, inviting speculation as to meaning. This painting is now apparently lost. Judging from the reproduction that has survived, it resembled the expressionistic work Hartley would do in Germany (fig. 16) and echoed Matisse's energetic brushstrokes. Because they were less abstract and therefore more readily understood, *Lucifer* and *Still Life* were considered by one reviewer to prove that Dasburg "knows color and form, that he has mastery of line, and that he can be perfectly intelligible by means that appeal to normal comprehension." *Lucifer* was favorably commented upon because "it looks right from the front, from the rear or from whatever other angle it may be seen.[38]

One small painting of the 1913–14 period has survived that gives us some indication of what these paintings looked like (see plate 1). No recognizable subject impinges upon the primacy of the bright colors. Groups of "petals" or fanlike forms create a feel of swirling directional movement. Dynamic brushwork in an ambiguous space further animates this painting, in which color is its own justification.

During the first week of August 1914, Europe erupted into war. On August 8 Dasburg sailed for France, where Mabel and John Reed had gone; as he said years later, he had a compulsion to be there, to be a part somehow of the conflict. When he arrived in Paris it was a deserted city. Flags hung proudly from every window along the boulevards. Dasburg tried in every way he could think of to serve his native land but was rejected at every turn because of his physical condition. The

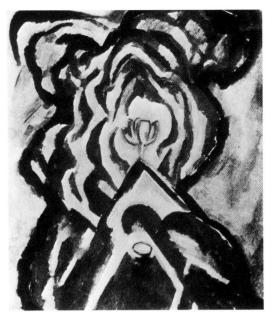

Try it this way

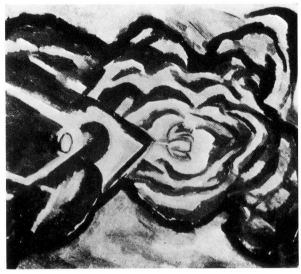

Try it this way

?

FIGURE 15. *To Mabel Dodge No. 2,* 1913, as shown in the *New York World,* March 1914. Oil. Original lost.

Try it this way

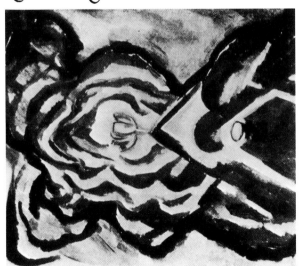

Try it this way

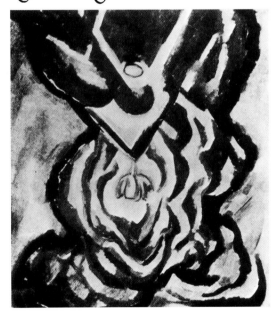

34

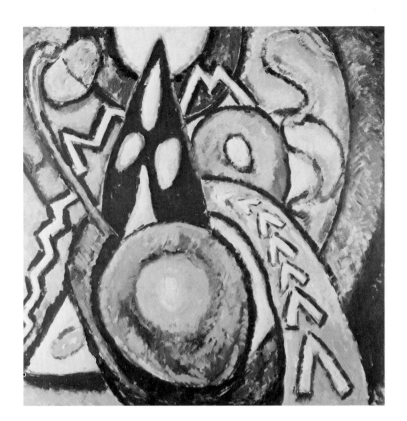

FIGURE 16. Marsden Hartley, *Movements*. 1915. Oil on canvas, 47¼ x 47¼ inches. Collection of the Art Institute of Chicago, Chicago, Ill.

war was coming closer to Paris each day; the guns at Senlis could be heard. Soon after, the virtually abandoned streets of Paris were filled with taxis carrying soldiers to the front. The soldiers moved out and the refugees moved into the city. As the front on the Marne held and Paris settled into the routine of war, Dasburg became curious about the destruction wrought by the guns he had heard. He took a train from the Gare St. Lazare in the direction of Rheims, which had been badly damaged. When the train came to a halt he got out and began walking toward the ancient cathedral city. Years later he recalled, "It was in the autumn, the country was lovely. Every now and then, through a railroad cut, I could look down on the long freight cars filled with wounded."[39] Soon he encountered two reporters who were leaving Rheims. They convinced the curious artist to turn back, since German snipers were still active in the vicinity. When Dasburg got back to Paris he met John Reed at the Cafe du Dôme and told him of his experiences. Reed, always anxious to get as near as possible to the fighting in order to report better on the war, persuaded Dasburg to join him in a second trip to the fighting area. They walked all day, from village to village, until nightfall. Dasburg, with his alert eye and his talent for colorful description, remembers that "a great harvest moon came

FIGURE 17. Dasburg at Mabel Dodge's cottage, Provincetown, Mass., where he visited her during the summer of 1914 before he went to Europe. Photograph from the collection of Alfred Dasburg, Santa Fe, N.M.

out through golden leaves and shone on fields of grain and the litter of battle. All through this debris, lovely violet crocuses were blooming."[40] As evening approached, Reed and Dasburg became hungry. Instead of carrying on the practice they had followed of going around the larger towns, they entered the next one they encountered to search for food. Soon they found in the dark a sign on a door indicating that the building was a hotel. They pounded on the door and to their surprise and embarrassment it was opened to reveal French officers gathered around a brightly lighted table covered with maps. For the intrusion the two Americans were arrested and directed to report to the commandant the following day. After identification and questioning, the commandant lectured the two adventurers on the great danger they were in and sent them back to Paris. Since Dasburg could not help fight the war, and art life in Paris was at a standstill, he returned to New York before the end of 1914.

In 1915 Dasburg again had his work shown at the Macdowell Club. From November 18 to November 28 he exhibited examples of his abstract and

semiabstract paintings alongside the work of eleven other American artists, including his friends George Bellows, Robert Henri, John Sloan, Edward Hopper, and Henry Lee McFee. This group was considered innovative at the time, but only one of the group, McFee, attempted to use the lessons of Cubism overtly, and his pictures were conservative by Dasburg's standards. Dasburg had become a leader among these artists, although a number of them were older than he.

The short period during which Dasburg truly was a Cubist was drawing to a close in 1915. Because so few of his Cubist paintings have survived, it is appropriate to give special attention to *Sermon on the Mount* (plate 2), a fine, small watercolor, probably painted in late 1915, that was one of his last Cubist works. It was painted in either Woodstock or New York City and is a pure invention; that is, no particular subject was analyzed in Cubist terms. The overall forms evolved as the various parts were painted in response to the demands of the initial marks until there was finally a satisfying composition. A few other watercolors of a similar nature, now lost, led up to this picture. Dasburg recalls that in all of them he used fractured elements, semitransparent passages, and subdued earth colors to create a dynamic arrangement of thrusting shapes that had no specific meaning. They were more intellectual exercises than emotional responses to concrete subjects or states of the artist's mind. It was unusual for an American painter or even for a European Cubist to produce a purely abstract composition. Rarely did Picasso or Braque go so far in Cubist pictures. The course he followed is a measure of Dasburg's logical mind and eagerness to explore new ground.

When the painting was finished, Dasburg almost immediately gave it the title *Sermon on the Mount*, which referred more to the artist's spontaneous reaction to what he had painted than to any formal characteristics of the composition. It may also reflect his interest in literature. He has not been especially religious but reads the Bible regularly as literature and has been an avid if random reader of the classics all his life. He would often read to Johnson and she to him. He read Virgil's *Aeneid*, Shakespeare, the novels of Balzac, and the works of Schiller and Nietzsche. Reading widened his horizons and, while not directly influential as far as his work was concerned, gave him a sense of the importance of form.

In March 1916, in order to give greater exposure to the work of American artists who had absorbed lessons from the French section of the Armory Show or directly from European contacts, the Forum Exhibition, held at the Anderson Galleries in New York, featured modern American painters. Among the organizers of this major exhibition were Robert Henri, Alfred Stieglitz, S. Macdonald Wright, and his brother Willard H. Wright, author of *Modern Painting, Its Tendency and Meaning* (1915) who was the American critic writing most sympathetically about

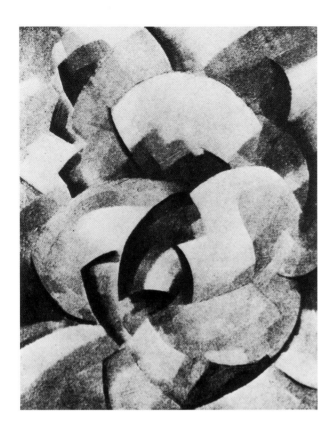

FIGURE 18. *Improvisation to Form.* C. 1914. Oil. Present whereabouts unknown.

FIGURE 19. *Improvisation.* C. 1914. Original lost. Photograph from the collection of Alfred Dasburg, Santa Fe, N.M.

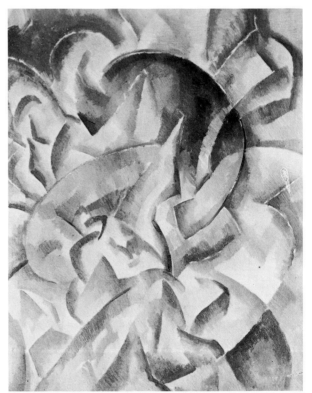

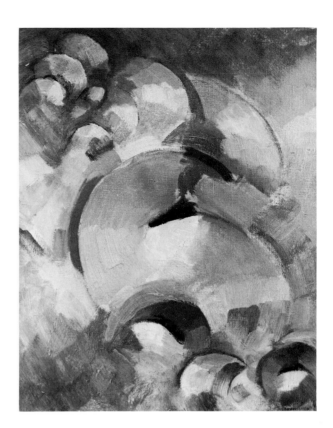

FIGURE 20. Morgan Russell, *Synchromie Cosmique*. 1915. Oil on canvas, 16½ x 13¼ inches. Collection of the Munson-Williams-Proctor Institute, Utica, N.Y.

modern art. Stieglitz had once talked to Dasburg about showing work at 291. Macdonald Wright was on very good terms with Morgan Russell, Dasburg's longtime friend, and, of course, Henri was an early influential teacher of Dasburg. It was therefore to be expected that Dasburg would be well represented in this first large exhibition of avant-garde American art held after the Armory Show.

While beginning to turn away from abstraction, in this exhibition Dasburg showed nonobjective paintings that he had done a year or two earlier. Their titles, *Movement* and *Improvisation* (figs. 18, 19), exemplified his previous view that form and color could evoke qualities of movement just as music could. In the Forum Exhibition titles like these were not unusual, for similar ideas were being explored by a number of American artists. This exhibition announced quite clearly that traditional, recognizable subject matter was being increasingly forsaken in favor of form and color alone. Describing nothing but themselves were Marsden Hartley's *Organization No. 3* and Morgan Russell's *Synchromie Cosmique* (fig. 20), typical titles of abstract paintings on display.

Dasburg, like the other participants, wrote a statement for the catalog about his purposes in painting the works he was showing:

> In these pictures my intention has been to co-ordinate color and contour into a phantastic form that will have the power to stimulate one's sense of the aesthetic reality. In my use of color I am to reinforce the sensation of light and dark, that is to develop the rhythm to and from the eye by placing on the canvas the colors which, by their depressive or stimulating qualities, approach or recede in accordance with the forms I wish to approach or recede in the rhythmic scheme of the pictures. Thus the movement of the preconceived rhythm is intensified. This is what I mean by co-ordinating color and contour.
>
> My conception of rhythm is based on a simple tensional contrast of lines which will give the sense of poise, of balanced masses which in themselves constitute an interdependent unity. The other lines—the minor rhythms—are developed from the original lines: they supplement and augment the first simple statement of the rhythm, and are, in turn, a part of the original rhythm, partaking of its character. Like the leaves thrown in a stream, the minor rhythms are picked up by the central current and carried forward according to the direction of that current.
>
> I differentiate the aesthetic reality from the illustrative reality. In the latter it is necessary to represent nature as a series of recognizable objects. But in the former, we need only have the sense or emotion of objectivity. That is why I eliminate the recognizable object. When the spectator sees in a picture a familiar form, he has associative ideas concerning that form which may be at variance with the actual relation of the form in the picture: it becomes a barrier, or point of fixation standing between the spectator and the meaning of the work of art. Therefore, in order to obtain a pure aesthetic emotion, based alone on rhythm and form, I eliminated all those factors which might detract the eye and interest from the fundamental intention of the picture.[41]

Of the nonobjective works Dasburg showed in the Forum Exhibition only one, apparently, has survived (color plate 1). The color in this painting is closer to Cézanne than Russell's Synchromism work, yet many formal connections with the movement can be observed, such as the ellipses and arcs. The transparent quality of some of the forms also recalls Picasso's early Cubist paintings.

Willard Wright said that Dasburg was a "man who gives the ideas of others a

trial so that he may learn by their mistakes." The gyrating, almost weightless discs in these paintings were the result of careful study of Chevreul's *De la loi du contraste simultané des couleurs* and Rood's *Modern Chromatics*, the most influential publications on the subject.

When Dasburg painted his *Homage to Mabel Dodge* pictures in late 1913 and early 1914, he was one of the true leaders of the avant-garde in this country. We are so familiar with abstract art today that it is difficult to understand how daring these paintings were in conservative America. What seemed inevitable after his stays in Paris and association with the 291 crowd was not inevitable at all. A dozen other American painters had been to Paris, visited the Steins, met Matisse and Picasso, and seen the Kandinsky in the Armory Show. Only Hartley, Cramer, Russell, and Dove struggled down the same path as Dasburg, and two of them, Hartley and Russell, had done so when they went to Europe. Out of a synthesis of Cézanne, Cubism, and Kandinsky, the new art of Dasburg had evolved. His startlingly different paintings began to be seen in a context of works of a similar nature in 1914 when Hartley showed his abstract and semiabstract German paintings at 291 and Macdonald Wright's and Russell's Synchromist paintings were shown in New York at Carroll Gallery. While still not by any means accepted, abstract art was being seriously discussed and regularly exhibited in the United States. Dasburg was one of those who brought about the revolution in this country, but he gradually drew back from abstraction when he found little support for it. He seemed to lose his nerve, and other things, such as his love of nature, became more relevant to him as a person and as an artist.

By 1916 Dasburg's flirtation with abstract art had run its course. He had developed his mature style out of an amalgam of what he had learned about managing abstract shapes from Cubism with a strong underpinning of Cézanne. Now he returned to recognizable subjects, with nature as a starting point. At this period, he has written, he felt a sense of "emergence" into a more realistic mode. His canvas of trees and buildings painted in 1916 at Mabel Dodge's home at Finney Farm, Croton-on-Hudson (see fig. 21), gives a clear indication of the ingredients that were to appear in his landscapes for the next fifteen or so years. Dasburg's adoption of elements from the real three-dimensional world recalls in drawing and color the work of André Lhote, the French painter who codified Cubism. In the paintings of both artists, forms were simplified but recognizable and stated in geometric terms. Lhote, like Dasburg, was an influential teacher and continuously fostered discussions about Cubism. It was the work Braque and Picasso did in 1908 and 1909 rather than the later, more fractured pictures, that provided Lhote and

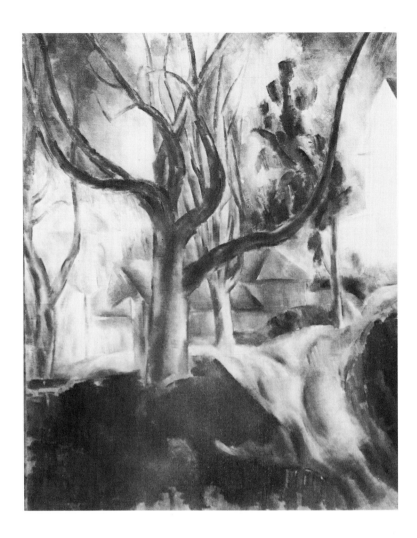

FIGURE 21. *Finney Farm.* 1916. Oil on canvas, 30 x 24 inches. Collection of Mr. and Mrs. Henry M. Reed, Montclair, N.J.

Dasburg with their inspiration. In their paintings, motifs retained their original identity, but a distinct order was imposed on what had been observed in nature. Color in their work was secondary to form, but Dasburg frequently orchestrated more forcefully his range of forms and colors to give special emphasis to architectural forms, such as the gray and white buildings at the righthand edge of the 1916 Finney Farm painting.

Dasburg taught in 1916 and 1917 at Miss Wheeler's School in Providence, Rhode Island, commuting during the fall and winter from New York City to the finishing school for young ladies. His presence greatly increased the interest in art at Miss Wheeler's, thanks to his good looks, sense of dedication, and convincing way of explaining the fundamentals of composition and color selection. Helen

Chase Drea, one of his students there, described the reaction of the young ladies to Dasburg: "With his crown of golden hair, wistful limp from a childhood accident, eyes as blue as the expensive cerulean we used so sparingly, women couldn't help falling in love with him."[42]

A sophisticated and gifted artist and teacher, Dasburg also had a great love of the land and the working of the land. He came out to Mabel's Finney Farm in 1916 to help get it in operation as a working farm, not just to use it as a rural hideaway. By the spring of 1917, thanks to his help, the fields were producing more crops than could be consumed. In the meantime, Reed was not present, and Dasburg no longer quite filled all of Mable's needs. She had begun to be fascinated by the painter Maurice Sterne as early as 1915. Born in Russia, schooled in Cubism in Paris, where he knew Picasso and Matisse in the period around 1909–10, he had come to New York City. On a round-the-world tour, he had settled in Bali to paint the dark-skinned people of that exotic island in a semi-Cubist fashion, but World War I had forced him to leave Indonesia. He returned to New York and exhibited his drawings and paintings in a show that Mabel visited. She was fascinated by Sterne's treatment of exotic themes and his skill as a draftsman. After buying a small work she met the artist, and soon he became her lover. To reduce the speculation about their relationship, she arranged for him to live in a gardener's house near her home at Finney Farm. There Dasburg and Sterne, who had become close friends, spent evenings discussing the war in Europe and talking about art.

Mabel, like Dasburg, found Sterne's vigor exciting. The fact that he was a Russian Jew was an exotic attraction. After living with him for over a year, she decided to marry him; she felt that her son, John, should have a father in the house, and she was afraid that Sterne would stray if not married. Even before the marriage there were a number of disagreements. Mabel and Maurice seemed to be attracted to each other sexually, but not so much otherwise. They found it best to be out of each other's orbit except for short periods of time. A few days before the rather suddenly decided upon marriage, Sterne consulted their mutual friend Abraham Brill, the famous Austrian-born American psychiatrist, about their incompatibilities. Brill advised that they continue temporary separations. As a consequence, instead of a honeymoon together, Sterne left his new wife and went off with friends to a ranch in Wyoming while Mabel stayed in New York City. Before leaving, Sterne told his wife-to-be that he was marrying her for sex and for her money; what he really wanted, though, was love and a sympathetic companion. In his autobiography he wrote, "Her talk of sex and marriage was a declaration of war between mind and matter—I was soon convinced that in my

case the physical had no chance. She challenged a man's potency, and most of the men she knew were defeated in the early rounds."[43]

She wanted to flaunt her hold over men. Once she read to Sterne a long affectionate letter from Dasburg. Sterne stopped her and took the Dasburg letter to his room. There he painfully read the complete letter. He liked Dasburg's clear mind and talent as an artist, but could not help feeling jealous of what he felt was the "out-pouring of a sensitive and perceptive soul, describing his suffering and frustration when at last his ardent desire was about to be consummated."[44] This letter had been written years earlier, and Sterne probably misunderstood the relationship between Dasburg and Mabel. There was a strong mutual attraction but not, at least on Mabel's part, the making of a love affair. After his marriage, Sterne decided to devote more time to painting and reassert his self-confidence. He wanted to paint people with dark skin, a subject he had found so stimulating in Bali, and he wanted to be away from his wife. Upon the recommendation of his friend Dr. Joseph Asch, he went to Santa Fe, New Mexico, in October 1917, and established a studio there. Painting was difficult; for him the Indians were not nearly as attractive a subject as the Balinese. Compared to the willing natives of Bali he had known, they were almost antagonistic to most white people. Mabel wrote to him frequently from New York. On November 13, her letter included an informative note about the relative market prices of paintings in New York. "I haven't seen anyone who was at the sale [at the Bourgeois Art Gallery] but Bourgeois telephoned me. [John] Quinn bought 15 or 20 pictures. Pascin went for $111 and Dasburg for $5.00! I haven't heard how I went [Mabel was painting a good deal at this time or she may have been referring to a painting of herself by Dasburg!]. Picasso went for $31.00. Your painting went for $70.00 with spirited bidding."[45]

In early December 1917, Mabel decided to have a look at New Mexico and see what her husband was doing. Although suffering from a throat infection, she made the long train trip to Santa Fe. The reunion was very pleasant, but she did not like Sterne's associates or Santa Fe, which she thought was too touristy. From someone in New York she had heard of the little town of Taos, located seventy-five miles north of Santa Fe. It sounded like a romantic place, so she hired a car and driver to take her and Sterne over the narrow roads along the Rio Grande to the small Spanish-American settlement at the foot of the Taos Mountains. Upon arrival she was immediately fascinated by the Indians and their way of life. She told Sterne, "Here I belong, and here I want to stay."

Mabel was immensely impressed by the mountain setting, the Indians, and

44

their tiered pueblo. Her reactions to New Mexico can be determined to a considerable degree from her comments, written a few years later, about Georgia O'Keeffe's first visit to Taos:

> When anyone has been living for years on the lower geographical planes and then suddenly reaches an altitude of seven or eight thousand feet there takes place an accelerated action of every part of one's mechanism. Everything is speeded up. The heart sends the blood racing to the brain, all the separate cells in the body seem to be enlivened, emotions are heightened and the different senses know a new swift life. Things appear visually enhanced, people revealed more fully . . . and seem brought further into being. . . .[46]

Soon, however, she tired of talking exclusively to the few people in Taos who were interested in art or literature. In late December she wired Dasburg and the young theatrical designer Robert Edmund Jones to join her at her expense and to bring a good cook from a New York City employment agency. A man named Seebach accepted the job, and soon after the new year began the three men arrived in Lamy, where they changed to the connecting narrow-gauge train for Santa Fe. The trio found rooms for the night, and the next day, in the brisk, cold mountain air, walked around Santa Fe in the snow. Dasburg recalls, "I will always remember the fragrance of burning cedar and piñon which hung in the air."[47] His first New Mexico letter to Johnson was written from Santa Fe on January 13, 1918. It gives us a good picture of a town that was part eastern, part Spanish rather than striving, as it has since, to be as Spanish-looking overall as possible.

> It was past midnight when we arrived and today it snowed so that I have very little idea of my environment. What I did see differs so little from forty-five minutes from New York that it is hard to realize that all this distance brings the west so close to the east in all that is modern here. The main street might be in Mt. Vernon [New York]. There are adobe houses in the older sections and Spanish is spoken as often as English, but when you pass the old familiar mansard mansion of New York with iron animals on the lawn it is like a bit of Kingston [New York].[48]

After their brief stop in Santa Fe, the men took the narrow-gauge railroad, called locally the Chili Line, north along the Rio Grande to Embudo. There Mabel had arranged for Oscar Davis, who owned the Taos touring-car stage, to pick them up and drive them to Taos. Dasburg vividly recalls this trip. "We followed a long,

roundabout road along the sides of a steep canyon. We got to Taos at sunset. Taos Valley seemed to me like the first day of creation with the gorge of the Rio Grande opening to the west, snowstorms trailing over the Taos Mountains and to our right, piñon slopes rising to peaks of the Picuris Range."[49]

Not knowing how long he would be in New Mexico, Dasburg had brought no paints or canvas, so he just enjoyed the place. Everything in Taos was a new experience for him, and even though the snow made getting around difficult, he rode on horseback to nearby villages and took Mabel on a sleigh ride. He relaxed and became acquainted with the traditions of the local Spanish Americans and Taos Indians.

Sterne had a great interest in non-Western art, developed during his stay in Indonesia before World War I. He soon was attracted to the unusual santos made by the Spanish Americans for religious purposes. Sterne began to make a collection of these paintings on wood panels and saints carved in the round in wood and then painted. His first acquisition of this type of art was a painting of a head of Christ crowned with thorns. Dasburg recalls Sterne saying of this piece, "How awful and yet so beautiful it is."[50] Dasburg shared Sterne's fascination with the work of the nineteenth-century New Mexico *santeros;* he saw in the santos a directness of expression and a manifestation of religious belief that were deeply impressive. Carved of cottonwood and pine, then covered with a thin coat of gesso and painted so as to appear more realistic, these simple, frontal statements of basic forms appealed both to his sense of mysticism and his fascination with geometric form. As with many things in which he became interested, Dasburg was soon somewhat of an expert on the subject. He also became interested in weaving done by the Spanish Americans. Bert Phillips, one of the founders of the Taos art colony, introduced Dasburg to the blankets and serapes woven on crude looms in northern New Mexico. During future trips to the state, Dasburg bought examples of the blankets that were especially fine and sold them to tourists for a good profit. His eye for artistic quality and unusual craftsmanship, and his leisure to seek out fine examples of native weaving, soon made it possible for him to become an authority on this aspect of folk art and to make a modest income at the same time.

Because it gives us an interesting picture of Dasburg's initial reaction to New Mexico, and of the still relatively undeveloped countryside, his first letter from Taos to Johnson is quoted in full.

This country is more magnificent than I ever expected. Yesterday when we left Santa Fe the storms broke and the sun came out revealing the environs of mountains and plains all dotted to the furthest horizon

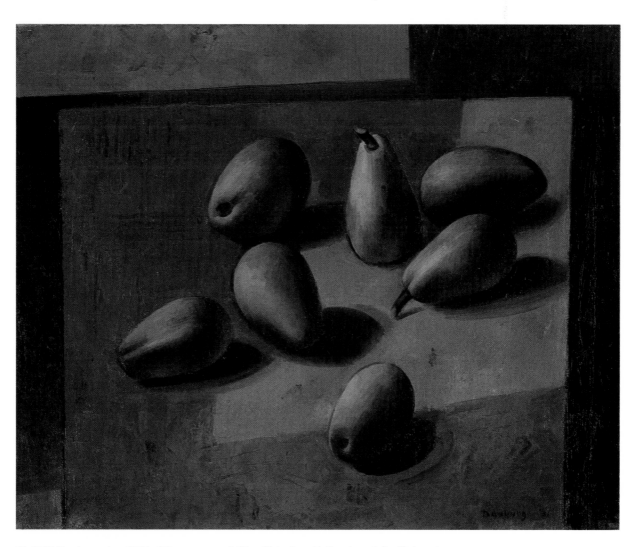

PLATE 5. *Avocados.* 1931. Oil on canvas, 16⅜ x 20 inches. Collection of the University
of Nebraska Art Galleries, Lincoln, Nebr.

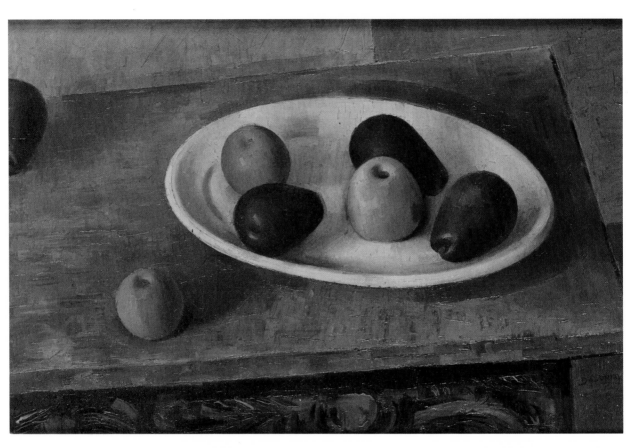

PLATE 6. *Apples.* 1920. Oil on canvas, 16 x 24¼ inches. Collection of the Whitney Museum of American Art, New York, N.Y., photograph by Sandak, Inc.

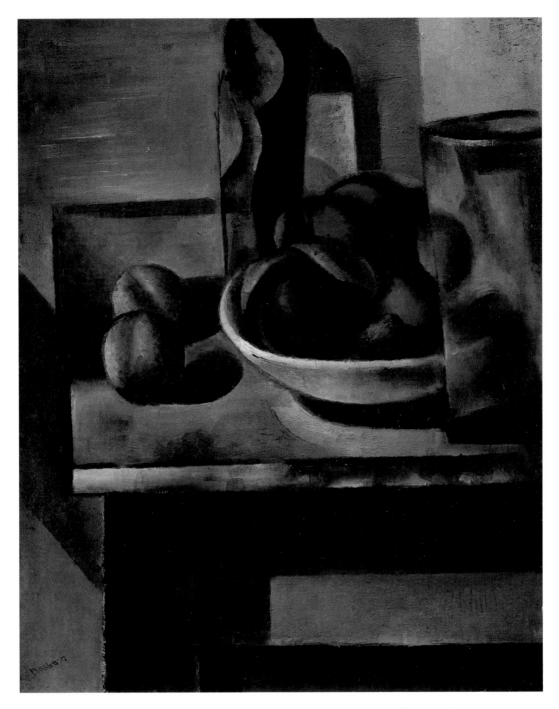

PLATE 7. *Still Life.* 1924. Oil on composition board, 16½ x 13 inches. Collection of Mr. and Mrs. Gerald Peters, Santa Fe, N.M.

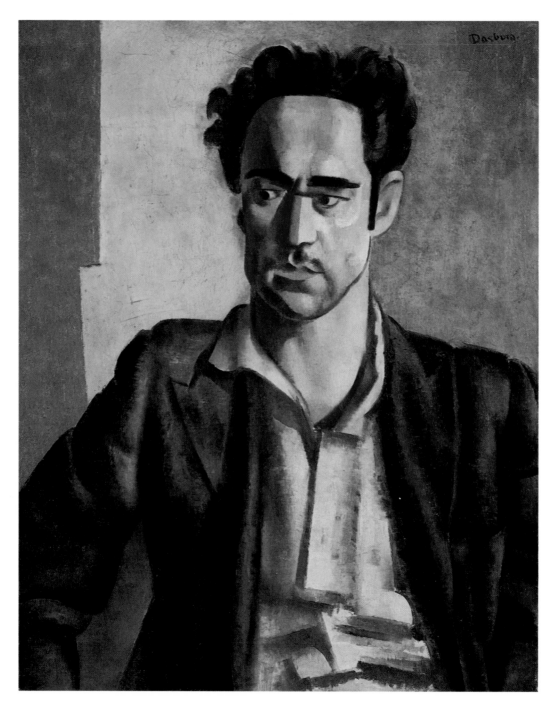

PLATE 8. *Judson Smith.* 1926. Oil on canvas, 29⅞ x 24 inches. Collection of the Dallas Museum of Fine Arts, Dallas, Tex., gift of Mrs. A. Ronnebeck.

with knobby evergreens. The highest peaks were heavily splashed with snow, that greyed the trees on the lower slopes like a hoar frost. Out of this they emerged down into the valley in their richest dark. The clearing had all the crystalline clarity and brilliancy of light that is like vibrant tinkling iciness of sound. In the hard transparency of sky were fractured stretches of clouds, their shape vanishing into the blue, while over the distant ranges was a turbulence of clouds in closer tearing against the peaks.

After an hour's ride we ascended into more barren country of desert and cathedral-like plateaus, fragments of dull red with crumbling rock on their slopes below. There the snow had melted and nothing grew but cactus and a little sage. The road serpentined thru the crotches of the hills that in places opened into cloistered valleys sheltering a pair of "Adobe" houses and wandering cattle. Thru one of these, passed the Rio Grande river, the course of which we followed up into the wide valley with ranches scattered thru the breadth of it. The caressing freshness of spring seemed to be here in the air and life of things. At Embudo where the river comes thru the mountains again, we were in the snow. Here started the thrilling part of the journey, a thirty mile trip by auto over mountain trails that a goat must have planned. To say that at times we were wonder-eyed with fright is a mild description of our inner state. In precarious places the car did not take the grade, so our driver would back down several hundred feet and try again with a fresh start, "making it" minus the chains. In one place while they were attaching them, another car came down, they got by, but that is all I know about it. How? is one of those things that sometimes happen contrary to the laws of gravitation. The drop on one side of us was at least four hundred feet to the river. At the very worst place where the car about stands on end and even the driver admits it is risky, a large boulder had come down almost blocking the entire road. This is passed like a mountain sheep without quite upsetting the car. In this instance I was only a spectator. The cook looked green and Jones like an ivory Christ. After we reached the crest the view spread before one is magnificent, the rolling desert reaches off for miles to the Great Divide, while across it cuts the winding canyon of the Rio Grande. Off to one side the mountains in chaotic grandeur half encircling the plain. In this hollow at their base is Taos. We found Mabel comfortably settled in a fine old Mexican house of ground-floor rooms

heated with fireplaces. Her son and his tutor are here, having come from Wyoming, where he spent the summer at a boys' camp. I have not seen enough of Taos itself to tell much about it. The Pueblo is about three miles from here. I think of you all the time and how much you will like it. We must plan a trip together and stay here long enough to get some work done. At the moment the climate is anything but mild, across the canyon the snow is said to be four feet deep and the thermometer is down to zero this morning.

One must be able to ride to do anything here; even for hunting they go on horseback. The game season is closed. Of that I will write you fully in another letter.[51]

He was full of the countryside and fascinated by the Indians. A day after his first message to Johnson he began the following very lyrical letter that richly expressed his responses to the new environment:

From here the mountains and the desert show some of their impressiveness. Taos is on the plain about four miles from the foothills built around a large square they named the Plaza. The houses are nearly all built out of a pinkish clay mixed with straw; their architecture of Spanish mission and Indian Pueblo. The roof is flat supported with beams and hidden below a parapet. Few of the houses are more than of ground-floor rooms, often built around a court, or opening on a walled garden. The effect of a number of these seen together is one of a simple massiveness that is only broken by the windows and the chimneys breaking up the skyline. Out at the Pueblos the Indians have massed their rooms in terrace formations to the height of six stories suggesting vaguely a sandstone cliff into which the swallows have built—or much like the cliff dwellers, only that here the entire mass stands separate. There is almost an uncanny impressiveness to see the Indians at the close of the day standing about on the terraces against the walls reddened by the light, shrouded in their blankets of black or white looking as if they were the risen dead come out of their tombs to watch the setting sun. Of them I will write you more after a better acquaintance because they differ from the popular idea of the Indians of our imagination. One has the freedom of this village after you have partaken of food with their governor; a sort of symbol of friendship—I would prefer some other act but eating as a mark of acquaintance. What has impressed me most about

them is that I do not in the least feel that difference of race that is so often a barrier between people. To me they are not as foreign as the Japanese or even Italians. Perhaps it is their great poise that gives them a quality of superiority over the white man, who so rarely has any whatsoever. Yesterday I walked up some of the lesser hills with my gun but saw nothing but tracks. Here one must ride a horse to really enjoy the country. There is no brush whatever and the trees are always widely enough separated for a horse to pass between and their footing is perfect. Only at the highest points is there any large timber, below none of it is more than twenty feet in height—all evergreens—Juniper, Piñon, Cedar and Pine, in number literally millions. If you send me your camera with films, I will take pictures of the animals for you and other things to give you an idea of the country. I have never realized how beautiful animals are until I saw them here on a free range. I want very much to take a trip "hereabouts" with you, for here you will find I think just what your interest demands. We must plan it if you care to do it with me. It is rather difficult to write an interesting description of the surroundings when one in a manner feels strange and detached. How I wish I were not lame and that my queer complex would vanish.'[2]

Mabel later commented on Dasburg's immediate reaction to New Mexico, and then related her response to his work:

Dasburg found the environment congenial and stimulating. He responded to the natural growth of the forms that met his eye on all sides, and he has remained and lived here, carrying on his own sensitive work in a happiness he had not known in cities. He had from early youth the precious faculty of perceiving the organic movement in nature and in man, and of being able to let it stream out of him onto his canvases. His trees live and reach upward, and, as there is a peculiar vibration in matter invisible to the eye, so there is also in his paintings of the adobe village streets and in his flowers and skies. His work is always alive and strong.[53]

While Dasburg was in New Mexico the war in Europe was in its final phase. The United States had entered the conflict the previous year and, even in so remote a place as Taos, there was great anxiety about the successes of the Germans. The fact that Sterne had bought examples of the simple New Mexico

santos made him an object of curiosity to the local people. Dasburg, also fascinated by the santos, started going from house to house seeking out examples of this type of folk art. During this time a rumor was circulating that the Germans were coming into the Southwest from Mexico. Some of the Spanish people thought that a man named Dasburg might be a German spy, and their patriotism was fanned when the boys who were drafted marched around the Taos plaza. Angry glances were cast Dasburg's way when he was sketching a landscape or going from village to village "spying." He recalls that the hysteria reached a ridiculous stage in regard to Seebach, Mabel's cook, who was abducted by a self-appointed vigilante group because he had a German name, was rumored once to have served in the Kaiser's household, and was living in the same house as Dasburg, who was drawing "maps" of the countryside.

Dasburg left Taos in May 1918, and he did not return to New Mexico in 1919, although his wife spent part of that summer as Mabel's guest in Taos. He spent the summer painting and teaching in both Woodstock and New York City. Teaching, talking, and writing about Cubism were becoming a way of life for him. One of his students during the summers of 1919 and 1920 was Kenneth Adams, who later followed him to New Mexico. When Adams was in Paris during the early twenties he met the painter Ward Lockwood, whom he persuaded to join him in the Southwest and who also became a devoted follower of Dasburg (see figs. 22 and 23 for an indication of the similarity of their styles). Later Lockwood served as head of the Art Department at the University of Texas and then held the same position at the University of California, Berkeley. In a tribute to Dasburg he said, "I know of no single artist in the Southwest who has influenced, or does influence, the work of younger painters more than Andrew Dasburg."[54] Mabel outlined more specifically the effect of Dasburg's teaching: "From the early years of his career he had a curious power over other artists. It almost seemed he had a magic hand that drew from the student potential creativeness that so often is unawakened and lies dormant a whole life through. He was able to communicate his own gift of seeing and stimulate in others the faculty so strongly developed in himself. He was really, from the first, a born teacher. . . ."[55]

While Dasburg was teaching in Woodstock in 1919 there was great agitation for a gallery where the many local artists could exhibit their work. He was a leader in organizing the Woodstock Realty Company, which was to acquire land and arrange for the construction of a suitable building where members of the Woodstock Art Association could show their work. The sole purpose of Woodstock Realty was to acquire property and a building, which it would rent to the

FIGURE 22. *Taos Valley.* 1928. Oil on canvas, 13 x 16¼ inches. Helen Foresman Spencer Museum of Art, University of Kansas, Lawrence, Kans., gift of the Clyde and Ward Lockwood Collection.

FIGURE 23. Ward Lockwood, *Ranchos.* 1930. Oil on canvas, 30 x 40 inches. Collection of Mr. and Mrs. Gerald Peters, Santa Fe, N.M.

51

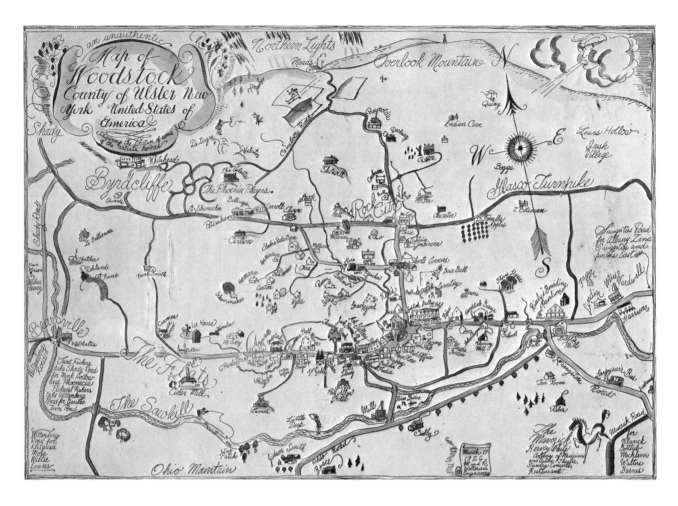

FIGURE 24. Map of Woodstock, N.Y., in 1926.

Association; thus the business function and the exhibition policies would remain separate. Stock was sold in the realty company, and the people of Woodstock subscribed generously to the offering.

The company located an ideal place for the gallery—a lot on the village green in the center of town where a general store had burned down. The site and an adjacent lot on which a house stood were bought for thirty-five hundred dollars. The company had an attractive gallery built in a simple New England style, based on plans drawn up by an architect who was a friend of Birge Harrison. At first there were separate galleries for the modern group and the conservative artists. This policy proved impractical, so it was decided that a member, for an annual fee

52

of six dollars, could hang any picture under thirty-six inches wide anywhere in the galleries. Many styles of art were represented. Such artists as Birge Harrison, George Bellows, Eugene Speicher, Ernest Fiene, Gaston Lachaise, and Alfeo Faggi regularly showed their work in the galleries. Prominent also were Dasburg, Henry Lee McFee, Konrad Cramer, and Charles Rosen, who was teaching the League's summer course. The League discontinued the summer program in 1922. After 1923, these artists were teaching landscape, portrait, and still-life painting, lithography, and design at the Woodstock School of Painting and Allied Arts.

The area around Woodstock became increasingly popular after World War I. The town supported a thriving printing press. Konrad Cramer, Andrew Dasburg, and, later, his close friend Henry Lee McFee were considered, as late as 1923, "three wild, woolly radicals." This is an indication of the isolated position after World War I of American artists who had chosen to follow Picasso and Cézanne.

Life in the early 1920s in Woodstock was enlivened by frequent parties, and sometimes by political controversy. In this period the Ku Klux Klan was very active around Woodstock. The artist and writer Peggy Bacon, her husband Alexander Brook, a painter, and Josh Billings started a modest newspaper called *The Hue and Cry*, printed on yellow newsprint. Bacon, who had considerable talent as a composer of doggerel, wrote light-verse comments for the paper about local events. Because of the unconventional style of writing, members of the Klan thought that they were being ridiculed. Other locals, sympathetic to the view of the Klan, also took offense. One was so incensed by what Bacon wrote that she dangled behind her car a doll that she called Peggy Bacon. Dasburg thought it necessary to take countermeasures, so he painted a cross on this woman's door and on the doors of others who resented the artists' presence in the community. This good-humored revenge was in keeping with the high spirits of the artists in Woodstock.

In 1920 Dasburg began a schedule he kept up for the next eight years; he wintered in New Mexico and spent the rest of the year in Woodstock, with frequent visits to New York City. He did his first serious drawing of New Mexico in the summer of 1920. It became his practice to draw around Taos or Santa Fe and make paintings from these drawings in Woodstock during the winter. Later the process was reversed. Whether he was living in New Mexico or in Woodstock, he found it difficult not to be influenced by his surroundings. Living and traveling in the dramatic mountains and valleys of the country around Taos fortified Dasburg's resolve to give up abstract art as an expressive vehicle. Intellectual doubts had begun in New York in 1916, when he showed five nonobjective works at the Forum

Exhibition, but New Mexico provided him with a more immediate reason to change directions. Under the influence of the southwestern landscape his pictorial language ripened and his philosophy of life deepened. The elemental majesty and power of nature became the primary focus of his artistic expression. Pure form and color were subordinated to the task of measuring the land and people of New Mexico in pictorial terms quite different from, though related to, his abstract work. He found that the immensely powerful rhythms of the hills and all-pervading clarity of the light did not lend themselves to Cubist reductions as neatly as did the subjects he had drawn and painted in Woodstock and New York. Cézanne's way of painting Provence, in southern France, which physically resembles New Mexico in many respects, remained Dasburg's model. He found in Taos a spirit of timelessness that provided him with an opportunity for reverie and introspection. This, together with the stimulation he received from living among the people of Taos and in the intimate presence of the landscape, explains to a large extent why he decided to spend so many years in such a remote and rustic setting.

In 1922 the English writer D. H. Lawrence and his wife Frieda, the cousin of the German Baron Manfred von Richtofen of World War I air combat fame, came to Taos as Mabel's guests. In 1924, they were joined by Dorothy Brett, a British aristocrat who had seriously studied painting in London at the Slade School and was an ardent follower of Lawrence. This created a tension-ridden group—Lawrence the prima donna and three adoring women, Frieda, Dorothy, and Mabel. Mabel had a talent for creating groups of friends, husbands, and wives that generated animosities. Dasburg remembers Lawrence as

> a man of many moods, gentle and lovable, often glowing with inner radiance when not possessed by an inflamed demon denouncing evil of one kind or another—the British aristocracy, women in general, and what he called the "American bitch" in particular, with a flow of language that would make a dockhand cringe. Outbursts I believe mainly directed at Brett, Frieda, and Mabel. Most memorable were his brilliant dissertations when expounding his dearest convictions. No one ever had a greater sense of play, especially when acting out charades. I still see him in a raincoat with an open umbrella commenting on the vileness of London weather.[56]

Lawrence and his wife were just part of the stream of visitors to Mabel's long, low rambling adobe house. She was genuinely interested in creative people and loved to talk with them about art and life. Lawrence was probably her most

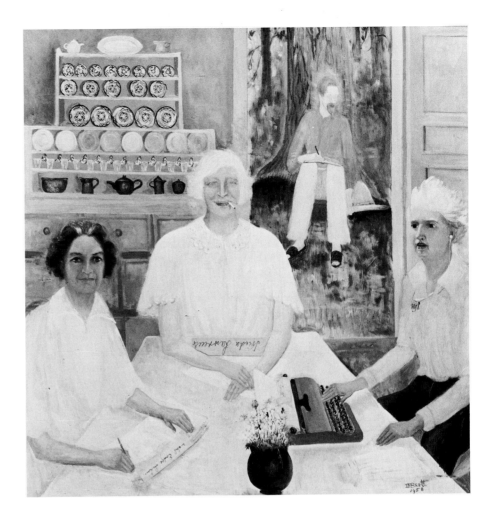

FIGURE 25. Dorothy Brett, *My Three Fates*. 1958. Oil on board, 27⅔ x 27¾ inches. Collection of Mrs. Harry A. Batten, Albuquerque, N.M.

distinguished long-term guest, but he found the tensions in the group that gathered around Mabel not conducive to creative work. To keep him in Taos, Mabel gave him a ranch in the mountains north of town. During his time in New Mexico Lawrence absorbed the rhythm of Indian life, the beating of the drums and the singing that went with the dancing. These he incorporated in *The Plumed Serpent*, although the book was actually set in old Mexico. Lawrence and others who visited Taos provided Dasburg with intellectual stimulus beyond his work.

In 1922 Dasburg divorced Grace Johnson (the two had not lived together for some years) and began living in Santa Fe with Ida Rauh, who had just been divorced from the writer and editor Max Eastman. An old friend of Mabel's from New York days, Rauh had received a law degree from New York University in 1904 but had never practiced. During World War I she became a member of the

Provincetown theater group. She both acted in and directed plays in New York City and on Cape Cod. A strong advocate of equal rights for women, she was active in Margaret Sanger's birth-control campaigns. In addition she was a sculptor, painter, and poet. Her best known work is a portrait bust of D. H. Lawrence which is in the University of New Mexico's Harwood Library in Taos. She and Dasburg stayed together until 1928. One of Dasburg's most sensitive portraits is of her. Many of his friends felt that Ida Rauh exerted an affirmative influence on Dasburg as a person and as an artist by means of her personality and her cultural background. During the six years Dasburg lived with Rauh they spent part of each year in New Mexico and usually summered in Woodstock.

By 1923 Dasburg's work had evolved from exuberant abstraction into a personal interpretation of Cubism with distinct Cézanne overtones. He still used what he had learned in the 1913–15 period about warm colors advancing and cool ones receding, phenomena he had explored extensively in his pictures of arcing disks of color. He had returned to representation for the simple reason that reacting in pictorial terms to observed forms gave him more satisfaction than pure invention. Angular geometric forms derived from nature still characterized his work even in this new direction. The pictures of this period reveal him to be a subtle, incisive analyst of the motifs he chose. With his modified Cézannesque style he combined a sense of order with surprising transformations of all kinds of shapes to make them distinct without destroying their identity. He planned his pictures with great care so as to free his forms from petty details in order to convey their basic character. A sense of substance linked his compositions to the real world of three-dimensional, heavy forms even when their pronounced angularity spoke of the artist's feeling of freedom to invent or alter to suit his special emotional response to a subject. This response was apparently largely physical, to judge from the stress on impersonal, nonhierarchical treatment of the elements in his compositions.

Dasburg's impressive article "Cubism: Its Rise and Influence," published in *The Arts* in 1923, is crucial to any understanding of the artist's own work. It is also helpful in understanding the period when Americans were assimilating signals transmitted from Europe about art's new directions. Dasburg had a clear understanding of the degree of acceptance in America of the Cubist idiom. He wrote:

> The influence of Cubism on American Art is apparent; yet in writing of Cubism in America one must hesitate to call anyone either its disciple or exponent, for "there are no Cubists"—none who call themselves so. Isms

and classifications are "taboo." The illusion of individuality has cast its spell upon the artist. He resents being associated with any particular group. To him classification implies a loss of identity. This attitude is so general among our painters that one cannot write of "actual Cubism" in America, but only of the effort.

With insight he explained the danger of using an overlay of Cubism to achieve a sense of modernism, commenting perceptively on the depth of the commitment of most American artists to new forms:

> This ambition to achieve the distinctly personal would be admirable were it not accompanied by a self-deception which, admitting nothing, takes from many sources the formal material for our art. We fail to recognize that form arises in personality and bears the impress of its origin. An idea can belong to all and become the way to individuality, whereas merely to adopt the results of another's use of the idea is essentially a negation of self. We lack the intellectual integrity to work logically within the limitations inherent in an idea. We want instead to gather what is best from many sources, forgetting that art is not compounded from extracts of different significant qualities found in great art. We have yet to learn that each development has a character of its own which remains forever intact.

Dasburg then wrote of the "contagious force of Cubism":

> This idea of combining a variety of forms of perfection into one complete ideal realization prevents any creative work being done which possesses the contagious force of Cubism. Usually we weave into the fabric of a new conception enough of the current traditions to destroy its integral character, a process of peaceful penetration wherein little is risked and much may be gained. Not until it is realized that originality never follows from this attitude of assimilation and refinement can we become innovators. Though we fail in this rôle there are, among American artists, men of unusual talent whose work compares favorably with the best being done in Europe, excepting that of a few great figures. Almost everyone that can be called "modern" has at some time or other shown an influence of Cubism in his work. Among these are Sheeler, Man Ray, Hartley, McFee, Wheelock, Demuth, Marin, Cramer, Burlin, Sterne, Wright, Haweis, H. F. Taylor, Dasburg, the Zorachs, A. Lohr, Baylinson,

Judson Smith and, lastly, Max Weber, who has worked more consistently within the discipline of Cubism and developed it further than any of these.

. . .

Nature and the conventions with which he may be familiar are the standards used by the unimaginative to appraise the new. For the modern artist, the objects and occurrences of natural phenomena are not art. Nature in itself is neither good nor bad; it exists—life is. For him no appearances, but causations—the underlying geometric mechanism—is the guiding principle on which he builds.

Dasburg then outlined a brief history of the development of Cubism in France. Next he cogently analyzed the aims and achievements of Cubism in its three major phases:

In its inception Cubism was unconsciously a geometric definition of a state of feeling induced by Picasso's preoccupation with the tactile sensations of mass and movement in the work of Paul Cézanne. A basic synthesis which for him became a plastic equivalent for three-dimensional forms.

Cézanne realized his art by the way of nature. Picasso, through the contemplation of Cézanne's achievement, found a method that created a new school. In one of his letters, Cézanne writes: "I see the planes criss-crossing and overlapping and the lines sometimes seem to fall"—a sentence vividly descriptive of the early work of the Cubists and bearing within it the germ of Cubism.

Cézanne, who remains today the inspiration and source of energy for "modern" art, opened up, not only through what he had accomplished but even through his own feeling of failure, new possibilities of expression that ultimately led to an abstract art—an art existing within its own material means, independent of the illusion of objective reality —such as the latest phase of Cubism, a phase so different from the first that the term Cubism hardly embraces it.

. . .

Cubism can be separated into three developments—movement, spatiality and pure form.

Cubism is a geometry of rhythm and an architecture of matter. Two considerations are fundamental to the understanding of rhythm. One is

the force of gravity, the other, the upward impulse in living things. All matter shows the effect of one or both of these conditions, and they are two important factors in the invisible moulding of all forms. The so-called static nature of inanimate things is controlled by one; the organic materializes under the influence of both. Movement as opposed to the static effect of gravity on inanimate things—as, for example, the formation and action of the human figure—implies a displacement from the center of gravity and a sequence of adjustments against resistance to a state of equilibrium. This adaptation is a constant sensory experience of man. He, in all his movements, instinctively seeks an attitude of poise and ease. Rhythm is the effect of the harmonious accomplishment of this action. And when the essence of this is achieved in a work of art, without expenditure of energy on our part, we receive a sense of freedom from the physical difficulties of a resisting world. These forces in the mechanism of growth are the underlying principles upon which a feeling for rhythm and rhythmic composition is founded.

The instinctive experience of our natures is then the truest guide for the proportioning and directing of form into significant symbols of rhythm. In this principle Picasso found a plan that served to coordinate the form element of planes. Not content with the bilateral displacements resulting through movement, he added yet greater and more vivid interest through asymmetrical surprises in the breaking up of his objects. This gave a complex and astonishing combination of dynamic and static elements. Here began the dissolution of the objective image until it ultimately became incorporated into the space surrounding it. A transformation obtained through the extension of planes through planes, forming an architectonic unit in which the remaining fragments of the dissolved objects were held together only by the law of association. Even though the sculptural aspect of things was destroyed and transformed into purely spatial sensations, the technique for bringing about illusional depth was still employed.

Painting has a two-dimensional objective reality, a plane on which depth and modeling are illusional occurrences supplied through the process of association. In the non-illusional elements of painting, such as color, line, tone, and in the unlikeness of images, exists a separation which for the painter should be the key to plastic space. Qualities that are dissimilar, like contrasts of color, differences of tone and line, exist on

the same plane only in a tactile sense, i.e., on the surface of the canvas; the difference of their appearance is a spatial interval.

Picasso with a fecundity of invention finally achieved the method in which the means he employs become the motive for his composition. In this last phase of Cubism, so remote from the original conception, the emphasis is upon the material reality of the means involved, color existing for color, and all the other elements used accentuating their own reality through the fundamental aesthetic law of contrast. An aesthetic achievement which in its finest examples penetrates into a high region, having a quality akin to great Buddhistic art—one of ultimate poise wherein the conflict of elemental forces is transcended.

. . .

For the gentle temperament, Cubism serves as a geometric web to support his lyrical theme. To the more energetic talent, it becomes a way into the wonder of creation. But for all, after the shock of its angularity and asymmetrical deformities, the influence of Cubism, with that of Matisse, resulted in a greater liberation from tradition than even Impressionism achieved.[57]

In 1924 Forbes Watson, the editor of *The Arts*, asked the artist Alexander Brook to write an article on Dasburg's work. Brook was pleased to carry out this assignment. He had known Dasburg since 1917 when, as a member of the Board of Control of the Art Students League, he had gone to Woodstock to see what was going on in the school's summer classes. He found Dasburg the unofficial leader of the artists there since he could talk very convincingly about ideas based on his own work and what he had learned in 1910 and 1914 in Paris.

Brook's article turned out to be about both the man and his art.

Dasburg's enjoyment of sheer paint is genuine and clearly apparent in his pictures, but this is in his case happily combined with a scientific understanding of what he is doing. Mentally he is a vivisectionist or rather one immersed in puzzle finding, while his intense human quality admirably counterbalances the former traits and prevents his work from assuming the aridity of the pure intellectual. . . . That Dasburg has charged about from one thing to another, executing many extraordinary somersaults and tight-rope acts during the last fifteen meteoric years, is

undeniably so; but he has always landed feet first, rescuing from each performance new impetus and a number of fine canvases.

He has been spending the last few winters in Taos, New Mexico, whence he brings back with him in the spring scenes of the countryside that give one an idea of the landscape better than those of any other painter associated with this fast-growing and popular colony.

Dasburg's landscapes have the authenticity of the place embodied within them condensed as much as possible, and are to be numbered undoubtedly among his best pictures. In them he is more at home, for here is color suited to his taste. Patches of light pinks, greens, blues, yellows and hosts of others, running the entire gamut of the palette, that have a nervous relation to each other which makes of the whole a peculiarly elaborate pattern.

Dasburg flaunts cleverness quite unreservedly, treating it as a thing too precious to forsake. He is a brilliant conversationalist in paint with something fundamental to say.[58]

In the landscape paintings reproduced in Brook's article (figs. 26 and 27) we can follow some of the complex reasoning Dasburg went through when confronting the motifs he chose. He had learned from Cubism to get beneath the crust, to find a synthesis of forms that would convey the primal nature of the land's formation. In northern New Mexico, man had imposed an order on part of the land for hundreds of years to suit his purposes, laying out fields that could still be readily cultivated and building houses that clustered together for the economy of common walls, protection against the Indians, and social convenience. Dasburg followed the basic designs of the multicolored fields and the rhythms of the rooftops, fitting them snugly against a silhouette of the nearby Sangre de Cristo Mountains. Much that he had discovered while painting Cubist still-life compositions was applied to these landscapes. Today many of them can only be seen in black-and-white reproductions, since their present whereabouts are unknown. The monochromatic representations make us more aware than would seeing the actual paintings of the patterns of light and dark that break up the space into slanting rectangular fields and square, blocky buildings interspersed with less geometric forms based on bushes and trees. The viewer will notice that Dasburg greatly exaggerated the flatness of the forms in these pictures to conform to the canons of Cubism. His treatment of the mountains, however, resembles Cézanne's paintings of the mountains near Aix.

Light playing across the folds of the mountains gives them an organic character that well served Dasburg's aim of evoking the bulk, weight, and subsurface structure of the earth's crust as it was thrust up above the high plain east of Taos.

One of Dasburg's close friends in Taos was the poet Willard (Spud) Johnson, who published a little magazine in the twenties and thirties called *The Laughing Horse*. For a 1925 edition Dasburg made some woodcuts. Mabel's house on the edge of Taos and a portion of Taos Pueblo are the subjects of two (fig. 28). Dasburg gouged out irregularly shaped patches of wood to convey a feeling of intense sunlight on the adobe walls, for in a woodcut the part cut out does not take ink and prints the color of the paper—in this case white. Dasburg greatly simplified the basic shapes of clouds over Mabel's house and the saddle-shaped Taos Mountains over the pueblo. The bold pattern of black and white conveys in rudimentary fashion the blockiness of the buildings, with a minimum of detail, while also revealing the process whereby the pictures were made. Even at this small scale and in a medium to which he was not accustomed, Dasburg united the thematic content with rhythmically repeated shapes that engender a feeling of controlled mass and space.

In 1925 Dasburg's work was exhibited with that of Katherine Schmidt at the Whitney Studio Club. This was one of the few times a group of his pictures was shown in New York in the mid twenties. The Whitney Studio Club, the forerunner of the Whitney Museum of American Art, was founded in 1918 by Gertrude Vanderbilt Whitney. It was directed by Mrs. Whitney's friend Juliana Force. In 1914 Mrs. Whitney (who, it may be recalled, made possible Morgan Russell's stay in Paris) opened her studio to show and sell the work of young and innovative artists. Out of this venture grew the club, which served as a showcase for Dasburg's work and that of many of his friends and acquaintances.

The critic H. E. Schnakenberg wrote in *The Arts* of Dasburg's work in this show, "There are still insistent bits of Cézanne, of Renoir and of Picasso, but the work, as a whole, is well under control. The fusing of different styles is about complete. New Mexico, where man and nature have united to make of the landscape a vision to delight the artist inclined to abstraction in art, has probably been the reason." He then called attention to a "mannered" portrait of Dasburg's son Alfred and a sketch of Matunuch Beach. His concluding sentence gives us an indication of Dasburg's reputation for intellectual analysis and his power to create very logical pictures. Describing the sketch of rows of patterned white breakers, Schnakenberg wrote, "For once Dasburg gives no sign that he knows exactly how things are done."[59]

FIGURE 26. *Landscape, New Mexico*, Reproduced in Alexander Brook, "Andrew Dasburg," *The Arts* 6 (1924): 24. Present whereabouts unknown.

FIGURE 27. *Ranchos de Taos*. Reproduced in Alexander Brook, "Andrew Dasburg," *The Arts* 6 (1924):19. Present whereabouts unknown.

63

FIGURE 28. *Taos Pueblo.* 1925. Woodcut, 6 x 4 inches. Print pulled by John Sommers, 1978. Collection of Dr. and Mrs. Eugene Wasylenki, Albuquerque, N.M.

Possibly because of the Whitney Studio Club exhibition, Dasburg spent the summer of 1925 in Santa Fe, the reverse of his usual practice of staying in Woodstock and New York City in the summer and wintering in New Mexico. Another reason he stayed in New Mexico for the summer was that the Chappell School of Art, located in Estes Park, Colorado, which offered courses in painting and composition from mid June through September, arranged for him to teach in Santa Fe, along with such prominient New Mexico artists as Ernest Blumenschein, B. J. O. Nordfeldt, and Walter Ufer.

In the winter of 1925 Dasburg was actively dealing in Indian artifacts, as he had done almost from the first time he arrived in New Mexico. He was selling a few paintings but probably depended for his livelihood upon the sale of Indian

material and what he received from teaching. He wrote to Mabel, "The Heye Foundation have sent me an offer of $150.00 for the Taos shield. I wrote and told them I could not sell it to them until I am released by you to do so. You and Tony [Mabel's fourth husband, Antonio Luhan, a Taos Indian] talk it over and see if you can decide that it will be better there than in Taos where it may get lost for all time."[60]

In Santa Fe, Dasburg became a close friend of the poet Witter Bynner. In 1926, Dasburg, Bynner, John Evans (Mabel's son), and the painters Wladyslaw Mruk and B. J. O. Nordfeldt founded a company to deal in Spanish and Indian artifacts. They recognized that more and more tourists were coming to Santa Fe and that some were staying on to become residents. Often these newcomers would furnish a whole adobe house with artifacts of the region. The partners' Spanish and Indian Trading Post was a success. Located in the center of the old city across from the famous Harvey hotel, La Fonda, it looked very much like a museum. Each partner put up $500, and sales were over $27,000 the first year. Soon Dasburg realized he was not cut out to be a merchant and returned to painting. He took his share out of the $37,000 inventory that had been built up of items he had helped select. This gave Dasburg the first real capital he had ever had.

Dasburg's trade in Indian goods was not confined to Taos and Santa Fe. From the land of the Hopis in northern Arizona, he wrote to Mabel Luhan in New York, apparently with reference to an exhibit of Indian objects she wanted to hold, "Use the collection I have at Bourgeois [gallery] for your exhibition. He has done nothing with them. I want to spend the year out here and they may be the way of doing it. I must get $800.00 out of this lot for myself." In the same letter Dasburg again revealed his sensitivity to places, and in this case also to people. "The winds are sifting the sands of Hopi-land. Have you ever been on this prow of Walpi on a day like this? Only the arrows of an unfriendly world could have driven a people to seek shelter on such a spot. I like it here. The Hopi are an imperial lot. The silent sinister standing of the Zunis began to awaken some hidden antagonism in me."[61]

Although Dasburg was relying on his Indian crafts business for much of his income at this time, he was still painting as actively as ever. The path he had begun to follow in 1918 may be said to have arrived at its destination in 1926 and 1927. Painting still-life compositions, landscapes, and a few portraits, Dasburg treated all three subjects so as to stress their cubic dimensionality. Subjects were usually placed so that light raked across them, causing the shapes to stand out in relief. In this way shadows became interesting as semiabstract forms that complemented the fully illuminated areas. Details were abbreviated, and small

geometric forms were stratigically located in a composition to serve as stepping stones for the eye. Frontal forms, parallel to the plane of the picture and simplified of all extraneous detail, made his subjects monumental, far beyond their natural size. The mosaic quality of the pictures of this period makes us especially aware of the underlying geometry.

In painting trees as repetitions of forms, a subject he had begun to deal with in 1916, he responded to the patterned recurrence of the trunks as well as the intertwining limbs. He ingeniously filtered out elements that distracted from a spare embodiment of the rhythms he felt. As he did in so much of his work, he echoed forms in his tree paintings and drawings to create harmony out of the jumble of shapes he encountered in nature (see figs. 29-32). The disciplined openings between the branches of the trees in his pictures are like stops in music. The seemingly meandering limbs were not painted to reflect what he had seen so much as to serve as variations on the shape of more prominent elements in a system of strong and weak "beats." Houses frequently can be seen behind a screen of trees. They serve as geometric elements or foils for the curving branches of the trees. Also they offered an opportunity to introduce warm colors representing brick walls; such colors tend to advance toward us and thus could limit the illusionistic depth in this type of picture. In these tree paintings done in the late teens and the twenties, paint was applied in small patches, usually roughly rectangular. Piece by piece, the artist created cylinders, which became tree limbs or trunks under his skilled hand.

In examining more intimate paintings of this period we should take note of the small but very satisfying *Still Life* (plate 3), painted in 1918, after Dasburg returned to the east from Taos. While related to Cézanne's customary reduction of forms, this particular work could not have been done without a knowledge of Cubism. It shows some pears spread out on a tabletop and in a bowl placed in front of two glass vessels, one a clear, wide-mouthed jar and the other a narrow-necked, juglike container. Leaning against the table, on which the artist had so obviously arranged these objects, he painted a framed picture. The table in the composition is cut off about a foot from the floor, as is the picture frame. The other picture frames are tentatively indicated behind the table. The relationships between the various geometric forms convey a sense of order without being completely fixed or static. A comparison of this Dasburg picture (fig. 33) with paintings of a similar nature by Picasso (fig. 34) and Charles Sheeler (fig. 35) gives us an indication of his use of the language of Cubism. All three artists worked within the austere bounds of this new cerebral language. The crispness of their

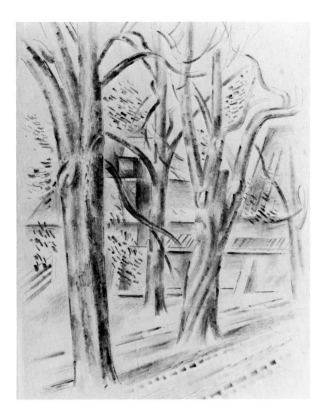

FIGURE 29. *Finney Farm (On the Hudson).*
C. 1919. Conté on paper, 22¾ x 17 inches. Private
collection, Taos, N.M.

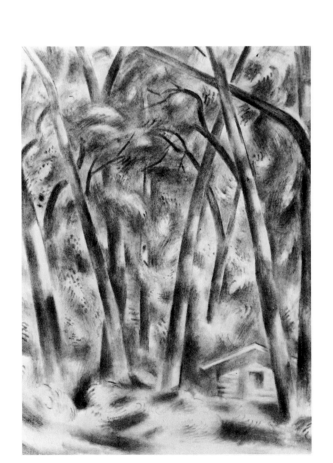

FIGURE 30. *Trees.* C. 1919. Sepia, 22⅛ x 16¼
inches. Collection of the Colorado Springs Fine
Arts Center, Colorado Springs, Colo., gift of Mrs.
Meredith Hare.

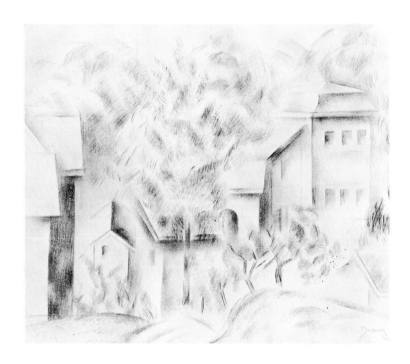

FIGURE 31. *Landscape.* 1920. Pencil on paper, 12⅜ x 13⅞ inches. Collection of the Whitney Museum of American Art, New York, N.Y.

FIGURE 32. *Trees.* 1938. Pencil on paper. 18 x 13¾ inches. Collection of the Fine Arts Museum, Museum of New Mexico, Santa Fe, N.M., photograph by Arthur Taylor.

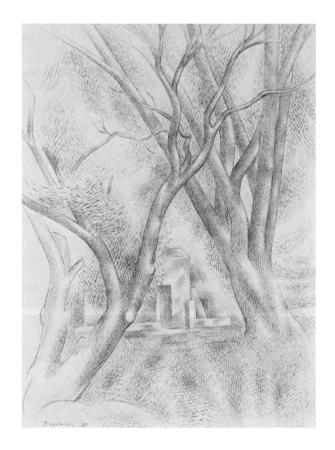

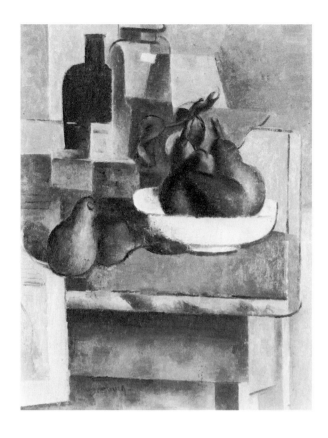

FIGURE 33. *Still Life.* 1918. Oil on canvas, 16 x 13 inches. Collection of Mrs. Oscar Howard, Westport, Conn., photograph by George H. Cardozo, Green's Farms, Conn.

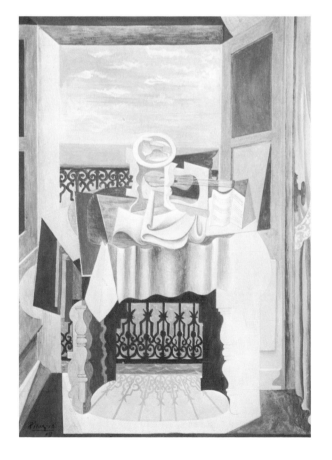

FIGURE 34. Pablo Picasso, *Table in Front of Window.* 1919. Oil, 13¾ x 9¾ inches. Private collection, New York, N.Y.

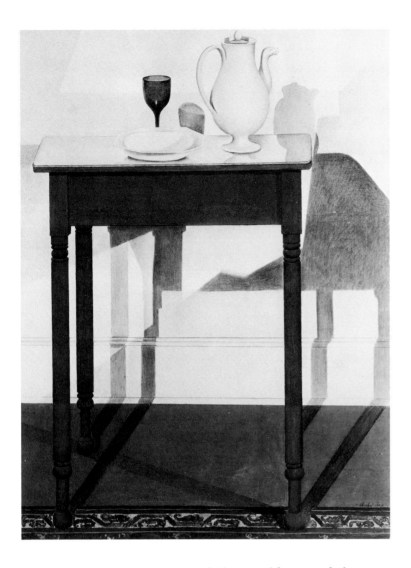

FIGURE 35. Charles Sheeler, *Still Life and Shadows*. 1924. Conté crayon, water-color, and tempera on paper, 31 x 21 inches. Courtesy of the Columbus Museum of Art, Columbus, Ohio. Gift of Ferdinand Howald.

forms and the equilibrium of the tensions established across the surface of the pictures and into the three-dimensional space were achieved largely by keeping the major elements parallel to the picture plane and arranged like flats on a stage. The tangible but abbreviated character of the simple objects represented varied from picture to picture. In Dasburg's painting the spatial position of the objects is somewhat ambiguous, whereas in Sheeler's composition one can chart quite accurately the relative front-to-back and top-to-bottom relationships of the objects. In Picasso's picture the elements are clear-cut, but their position is ambiguous because of the compression of space in the center and the opening out of space beyond each side of the table.

Inanimate objects like those in the 1918 *Still Life* were for Dasburg like chess pieces to be manipulated, bringing into play the intellect and emotions. Sheeler, we sense, was more interested in a tidying-up process, a classic regularizing of the arrangement to make it more easily understood. Picasso, on the other hand, joined the parts together in a tightly controlled organization, which he made dynamic by tilting the still-life objects up toward the picture plane and combining them in a fashion open to various space and time interpretations. He played the central elements against deep space to hint at the nature of the objects on the table around which one could step for further information or to enjoy the open air and infinity of the expanse to the horizon.

The 1918 *Still Life* was followed by dozens of others that posed similar problems. If we look at fully developed still lifes of this period, such as *Poppies* (1923; plate 4) and *Tulips* (1926; fig. 36), we can see how well Dasburg unified the various elements. The petals and leaves in such pictures are as important as the vase, the table, the floor, and the wall. All parts are made to fit snugly and logically into the overall pattern of the composition. The artist confers upon each part an equal feeling of importance. Many painters would see the bloom as the reason to place the flowers in a vase, the vase being merely a suitable container for the examples of nature's beauty brought into the house. This was not the case for Dasburg. With care and caution he studied the flowers and all that would be included in his paintings, assimilating the complexity of the shapes and creating a system whereby each ingredient in the mixture was reduced to the same sense of substance. He included in his pictures only as much detail as was necessary to hold in balance the collection of different forms.

This is an important point when considering the special characteristics of Dasburg's work. What Dasburg tends to leave out of a picture are trivial elements that would conceal our view of the characteristic shape of things. What remains in force is a clearer statement of the subject couched in terms of pictorial geometry. This cuts down on the jostling of our sensibilities. Our attention is concentrated. A Dasburg still life of flowers is not a painting of colorful blooms in the tradition of seventeenth-century Dutch flower paintings, which show the veins of the petal in such detail that they can be more easily studied than through a magnifying glass. Dasburg was not trying to conjure up the experience of being in the presence of a bouquet of flowers. He was interested in creating a *picture;* his subject was only a starting point for a lesson in balance and clarification. He asserted his independence of his subject, per se, by casting it in high relief in a compressed space. He went about making a picture very much as though he were a stone carver working

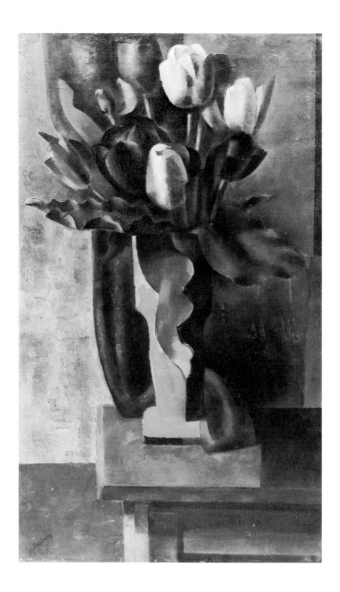

FIGURE 36. *Tulips.* 1926. Oil on canvas, 30 x 18 inches. Collection of the Los Angeles County Museum of Art, Los Angeles County Funds, Los Angeles, Calif.

with a chisel. That is, he paid special attention to the limited degree of detail he could include in a pictorial representation and still convey the true character of a form or group of forms. Dasburg's elegant but plain solutions to the pictorial problems he posed for himself can be likened to an inventory written in blank verse. In other words, his were references to the assemblage of forms with cryptic emphasis on the fundamental physical characteristics of volumes and voids.

Poppies awakens in us the pleasure experienced when examining the shape of a poppy's leaves and petals. Beautifully sustained in the sense of unfolding of the parts of the buds as they grow out of their stems and become

72

blooms. As an aid to understanding nature and its design, Dasburg's painting is wonderful to study. This was, however, only a small part of what was interesting to him as an artist. He was more concerned with the elements that made up the whole ensemble. Forms were chosen with scrupulous care to call attention to their relatedness.

In *Tulips*, the edges of the vase with its undulating lines, the stolidness of the slightly tilted Cézannesque table, and the shapes of the tulips and their pointed green leaves were all brought into harmony. As in all of Dasburg's work he took the motif, the vase of tulips, as a point of departure. With his carefully tuned creative antennae he sensed a pattern whereby the diverse elements in his subject could be made to operate pictorially as a dynamic whole within an artificial space. As soon as he put brush to canvas a process of construction began. This additive process was the opposite of the subtractive process that took place in his mind when he first studied this motif. Planes became very important, and the degree to which these planes could reflect concrete reality and still be at odds with that reality was considered. Geometric patterns were established with a piece of charcoal, then with color. Contours that were curving and exaggerated in nature were "corrected" to reveal them as forms—not as edges of leaves or undulating petals. Dasburg was always on the verge of freezing forms too firmly in his pictures, of tying them too tightly to one another, but he almost always avoided that trap by using a multieye perspective—a Cézanne/Cubist device—to maintain an underlying rhythmic feeling of forms operating in a purely pictorial space. Across the surface—varied by a tactile sensibility—he slanted forms at various angles into the picture space to set up a feeling of movement that would emphasize the transformations he was after in this and all of his paintings.

Still lifes had been a challenge to Dasburg since the day in 1910 when he had copied a Cézanne painting of apples. Few American artists of the first rank involved themselves so deeply with such motifs in the 1920s. In these paintings, even more than in his landscapes and portraits, he was concerned with the problem of combining like forms in a structurally consistent fashion. Keep in mind that problem solving was Dasburg's main concern in art. The objects in his paintings of fruit, though treated in a simplified but essentially literal manner, are to be seen as solutions to problems posed in a gravity-defying context. The tabletops are markedly slanted to serve as a flat rectangular background for the spherical forms; because of our knowledge of gravity, they also create a feeling of tension and detachment from reality. Cézanne used the same means of achieving structural clarity and viewer involvement in his still lifes—further indication that Dasburg was sustained by his knowledge of Cézanne and his once revolutionary

ideas. (It must not be forgotten that at the time Dasburg painted these still lifes Cézanne and Cubism were subject to public hostility and incomprehension even by professional critics.) Dasburg gets so much out of his more strictly executed, geometric, still-life paintings like *Avocados* (1931; plate 5) and *Tulips*, simply because the basic shapes interact in such a provocative manner. He carefully and convincingly paints the individual characteristics of apples, avocados, or tulips. The disposition of the rounded forms on tables or in vases varies from complex arrangements to an emphasis on individual elements, each element carefully placed to reveal surfaces and contours that only barely contain the mass that gives the fruit or flowers their spherical shapes. Radiating out from the core, the forms symbolically represent life and nature's bounty. Dasburg writes and speaks of nature with great, almost passionate sensitivity to beauty, yet as a painter he is as calculating as an engineer. Perhaps this apparent inconsistency is due to the difference between effortless, private talk, or letters to friends and family, and public statements in the form of pictures exemplifying formal theories to which he wishes to call widespread attention in the name of Modernism.

The subjects of early French Cubist still lifes were drawn from café and studio life in Paris. Carafes, wine bottles, musical instruments, newspapers, and cane-seated chairs alongside marble-topped tables were chosen as motifs. The Cubists' subjects can be said to be symbolic of the interior life of the artists, of their search for symbolism in everyday objects. While well aware of their symbolic significance, Dasburg usually selected his forms for their shapes and then proceeded to adjust them in a still life to get the most interesting juxtaposition across the plane of the picture and in depth. He felt that it was sufficient merely to draw the silhouette of a bottle as in synthetic Cubism, when placing it in the abbreviated space he evoked. To him the vessels were forms to be treated with little sense of "containerness." He did not use multiple profiles like those found in analytical Cubist paintings. Modeling was very limited—except in the case of fruits—and perspective was strictly controlled. He worked more like an Egyptian hieroglyphic artist than like Picasso. In the 1918 *Still Life* (fig. 29; plate 3) the flattened plane of the table and the indication of frames in front of and behind the still life compacted the space. His manner of representation also destroyed the usual textures and sense of softness and hardness we think of when looking at the objects he painted. Everything seems firm and durable. This painting is closer in spirit to Juan Gris than Picasso or Braque, which means it is a synthesis of the ideas explored initially by the Cubists. Two years after painting the still life with pears in a footed bowl, Dasburg painted a similar composition. In the 1920 picture (plate

6) space was treated in a much more realistic fashion. The tabletop was slightly upturned, and the white bowl of peaches and the other vessels were painted almost in the manner of an eighteenth-century genre painter, as far as a sense of mass and modeling is concerned. This change represents a distinct turning back to Cézanne and even to earlier artists rather than an exploration of Picasso's extension of Cézanne's ideas.

In 1924 Dasburg painted another tabletop *Still Life* (plate 7) in which he used what appears to be the same Art Deco vase found in the 1926 *Tulips*. This arrangement of fruit and a vase was not a point of departure for a new exploration of formal values. It was merely another problem in which he pared away all the nonessentials in order to give the "participants" in their area free space in which to interact. In a finely weighted juxtaposition, slightly off-vertical and off-horizontal lines, with rounded forms repeated, were united with carefully calculated colors, largely low-key blues, mauves, and browns. Meticulous planning of the interaction of this "house of cards" and spherical shapes resulted in a balance of forces that had obviously been highly ordered, almost to the point of dryness, or even tedium.

At times Dasburg's disciplined analysis of forms and meditative clarity of mind resulted in academically sound but less than fresh and exciting pictures. An occasional willful imprecision or dubious placement of a form would be welcome as an indication that his close-packed work was not formula bound. His attention to order as a kind of metaphor for God's system did not always succeed in intensifying or focusing the viewer's responses but did give his work a great sense of consistency.

Characteristic of Dasburg's 1920s portraits, which are related in many ways to his still lifes, are the paintings he made of his son, Alfred, at the age of about thirteen or fourteen (see fig. 37). The figure is frontal; light comes from the side to throw the features of the faces into relief, thus evoking in a classic fashion a strong sense of the three-dimensionality of the forms. The expression of the sitter is solemn—possibly because he had to pose so long for Dasburg, who was a slow, deliberate painter in oils. We are aware to a degree of the personality of the subject, but the style of representation speaks more clearly of the artist than of the subject himself. The background establishes immediately a sense of geometry. There is no evidence of an imposed framework or contrived formula within which Dasburg worked out his solutions to the aesthetic problems posed by the subject, but we can readily sense a personal approach to form if not the individual's personality. The representations of Alfred without a hat underline his unusual

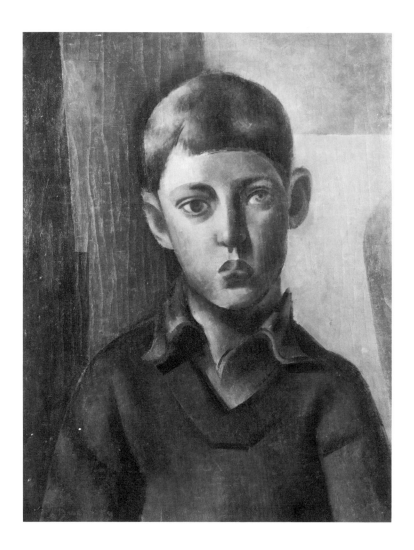

FIGURE 37. *Portrait of Alfred* (surviving portion). C. 1925. Oil, 24 x 17 inches. Private collection, Taos, N.M.

height for a boy of his age—he grew into a six-foot-plus man with a rather spare frame—and in the case of a portrait with a cowboy hat, not reproduced here, we can sense the robustness of the youngster. In both paintings the forms are completely filled out, which contributes to a feeling of monumental solidity.

This monumentality has nothing to do with the actual size of his subjects. In Dasburg's still lifes, a fruit such as an apple, peach, or pear that is only a few inches high can seem monumental. This quality is, in fact, the essence of the classicism that sets the paintings done in the 1920s apart from his earlier work.

The most severely geometric portrait Dasburg painted in the early twenties was that of his Woodstock friend Judson Smith (plate 8), a painter greatly

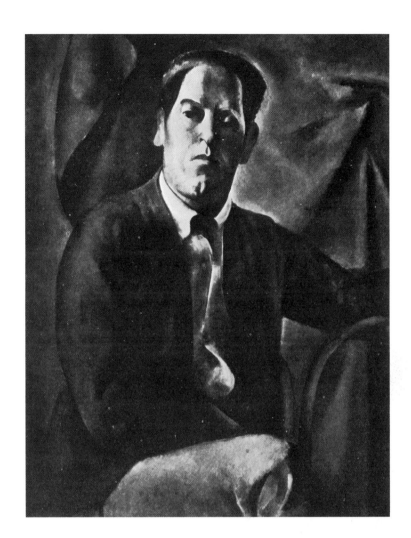

FIGURE 38. Judson Smith, *Portrait of Señor Santo*. C. 1922. Present whereabouts unknown.

influenced by Dasburg, as indicated by the Smith reproduced here (fig. 38). The whole composition is a semi-Cubist repetition of variations on the simple, flat, step form located at the upper lefthand corner of the picture. Nose, sideburns, shirt front, shoulders, and passages in the subject's jacket—all echo this basic form. The curly hair and collar of the shirt are counterforms that keep the likeness from being completely mechanical. As in all of Dasburg's portraits the light assures that the body and head convey a feeling of compacted mass placed in a limited space, with a good deal of vitality conveyed by the outline of the shoulders, dark side of the face, and simply rendered hair. Smith was a good subject, for he was near at hand, he was sympathetic to Dasburg's aims, being one of his followers in Woodstock,

and he had a physique and facial structure that permitted a summary physical treatment that was related to the subject but in truth was a systematic solution to a problem in form management.

Painted in about 1927 in Santa Fe in about three weeks, without preliminary sketches, was a portrait of a close friend, Cecil Clark [Wolman] (plate 9). In this case Dasburg was as involved with the Chanel suit and Paris hat as with the personality of the sitter, whose face was the last element to be painted in. This portrait is important for the insight it gives us into the way Dasburg managed so authoritatively to shape the pictorial elements of a motif into a coherent statement. The painting is both an account of the subject's features and an illustration of the artist's idea about form. It has little that is new in his art, but shows his mastery of his style. Characteristically, Dasburg limited the details and paid far more attention to relationships of hat to head and head to torso than to any glib evocation of his subject's personality. He relied on an overall effect, suppressing any inclination to elaborate this or that feature or part of the dress and using forms in several variations. The hands, beautifully executed, were loosely painted and provide an effective contrast to the deliberateness of the balance of the picture.

Dasburg has always had an independent streak in him. He made decisions about art on the basis of his deep feelings for fundamentals of structure and by considering a picture's emotional strengths. In 1927 he had reached a high level of prominence as an artist and as an exponent of modern directions in art. As a result he was chosen as one of six American artists to serve on the committee of admission for the Carnegie International Exhibition in Pittsburgh, probably the most important show in the country. Dasburg himself took third prize in the show; the first prize went to Matisse. Among the avalanche of paintings to be viewed for possible inclusion in this exhibition was one by a Scottish-born Pittsburgh housepainter named John Kane. This picture struck Dasburg as a genuine and vital expression of an artist's feelings about a subject he knew well. Titled *Scene from the Scottish Highlands*, it was passed over by the other jurors, but Dasburg felt so strongly about it that he said he would purchase it himself. Because of Dasburg's prompting the jury decided to accept it. This picture by a sixty-seven-year-old laborer who had never gone to an art school was imbued with the spirit that characterizes true folk art from all periods and from all countries. Unusual patterns, colors selected for their appeal to the artist, and obvious personal commitment to the subject were all there. Dasburg had developed an eye for these qualities in his winters in New Mexico collecting painted santos and Spanish-

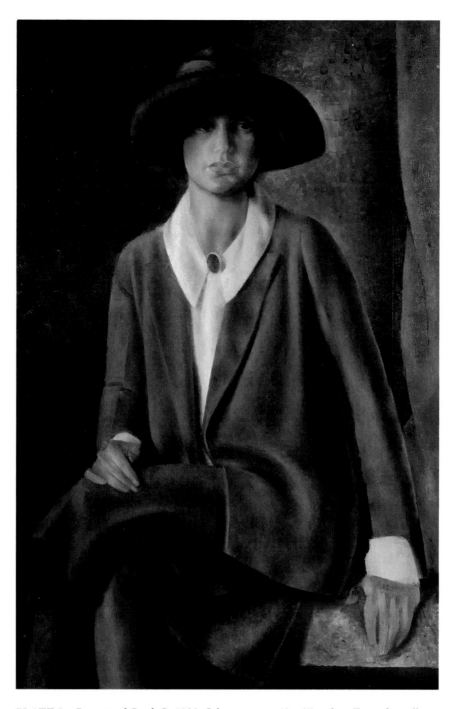

PLATE 9. *Portrait of Cecil.* C. 1926. Oil on canvas, 40 x 25 inches. From the collection of the Denver Art Museum, Denver, Colo.

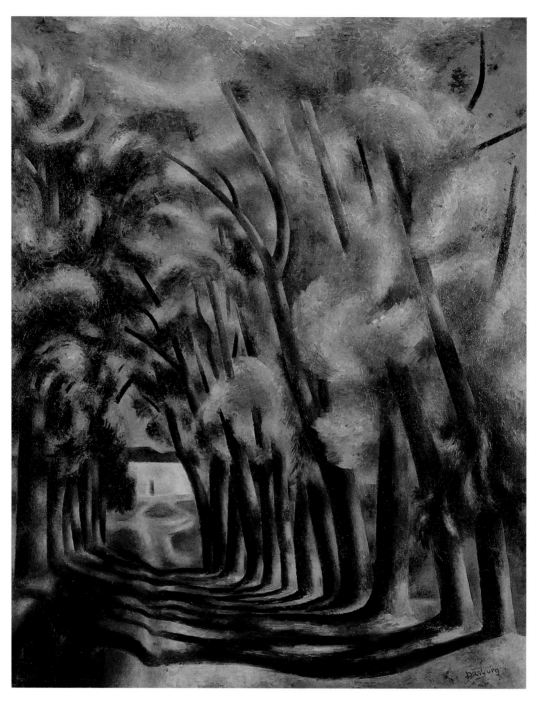

PLATE 10. *Chantet Lane.* 1926. Oil on canvas, 30 x 24 inches. From the collection of the Denver Art Museum, Denver, Colo., Albert Wassenich Collection.

PLATE 11. *Ramoncita.* 1927. Oil on canvas, 30 x 22 inches. Collection of the Cincinnati Art Museum, Cincinnati, Ohio, gift of Mrs. Howard Wurlitzer.

PLATE 12. *Angela*. 1923. Oil on canvas, 20 x 30 inches. Private collection, Arvada, Colo., photograph courtesy of Alfred Dasburg.

American patterned blankets. As confirmation of Kane's achievement we have the critic Henry McBride's comments:

> He was more than a painter, he was a poet in the use of paint. In the American section of the International Exhibition, where there are rows and rows of highly schooled paintings that contained little else than schooling, the meeting with the sweet feeling and novel approach of John Kane came upon one, as James Stephens, the Irish poet, once said, "like a breath of fresh air in a soap factory."[62]

Dasburg's sensitivity to Kane's talent was affirmed over the next three years when juries of admission to the Internationals in 1928, 1929, and 1930 accepted other examples of the housepainter's work. Major museums, including the Museum of Modern Art in New York, also acquired Kane's paintings. Dasburg's response to Kane's work indicates why he has always been such an effective teacher. He can see in different types of expresssion that which is genuine and fresh.

In the fall of 1928 Dasburg had a successful one-man show at Frank K. M. Rehn's galleries on Fifth Avenue in New York, which were also the agents for Charles Burchfield, Edward Hopper, Reginald Marsh, and other prominent American painters. He sold $9,950 worth of paintings. Five of these were still lifes—*Peaches* at $250, *Poppies* at $150, *Christmas Fruit* at $700, *Tulips* at $700, and *Yellow Tulips* at $800. Six were landscapes—*El Camino* at $1,000, *Apricot Tree* at $1,000, *Landscape* at $350, *Tree* at $600, *Pine Tree* at $350, and *Chantet Lane* (plate 10) at $800. Two portraits were also sold—*Ramoncita* (plate 11) at $1,200 and *Bonnie* (fig. 39) at $1,000. These were very good prices for a living American artist's work and indicate that Dasburg was certainly well regarded in the 1920s. One of the paintings that was not sold was the rather self-conscious and terse *Portrait of Loren Mozley* (fig. 40). It can be seen that the basic formal units in this 1928 painting were assembled in a more mannered fashion than those that make up the earlier Cecil Clark portrait. The forms are more complex and were developed locally in this picture. That is, clusters of forms or families of forms repeat and vary each other, as in the hands or the folds of the sweater worn underneath Mozley's jacket.

The portrait of Mozley, who was a student of Dasburg's at the University of New Mexico's summer art program in Taos, was painted under unusual circumstances. Dasburg spent the winter of 1927–28 in Taos living at the Don Fernando Hotel but painting at what was known as the Valdez studio nearby. He started a portrait of Tom Holder, who was staying in Taos but ususally worked on a dude

FIGURE 39. *Bonnie.* 1927. Oil on canvas, 26 x 22 inches. Collection of Mr. and Mrs. Donald S. Graham, Denver, Colo.

ranch in Arizona. Progress on the picture was interrupted when Holder heard of a job in Arizona and left New Mexico. This was most frustrating, for Dasburg was anxious to have another portrait for his upcoming show at Rehn Galleries. To calm down after hearing the bad news he took his shotgun and spent the day chasing ducks. This was not unusual, for he had always enjoyed hunting and often trampled over the countryside in New Mexico to maintain his health and psychological equilibrium. Soon Dasburg cooled off, for Mozley agreed to pose for his friend and teacher in the place of Holder. For the better part of a month Dasburg worked on the portrait of Mozley, who was shown in front of a beautiful quilt his mother had made. The composition was drawn with charcoal, with no details. Steadily the general areas and relationships evolved; then the forms were modeled and the color developed. He used raw sienna and Vandyke brown applied with flat sable

FIGURE 40. *Portrait of Loren Mozley.* 1928. Oil on canvas, 40 x 26⅛ inches. Collection of the Nelson Gallery, Atkins Museum, Kansas City, Mo., gift of Mr. and Mrs. Richard M. Hollander.

brushes. The jacket caused the artist a good deal of trouble, so Mozley gave it to Dasburg for further adjustments to this part of the portrait after the posing was finished. Since the painting did not sell at the Rehn Galleries show, it remained in Dasburg's possession, and years later he simplified the background. Its appearance today, therefore, has changed since it was shown in 1928.[63]

Elizabeth Cary, reviewing Dasburg's Rehn show for the *New York Times*, mentions a number of these paintings, including the Mozley portrait. She saw

> landscapes of New Mexico stained with exotic color, heavy hills chained to the planet earth and straining at their leash to follow the rolling flight of clouds, hot yellow fields punctuated by bushes of smoldering crimson and houses sweltering in color. Now and then cool notes, a green spiked

tree lifted against the sky like some medieval weapon; a cool blue in the hills, a white gleam in the clouds. Landscapes the reality of which is affirmed by their aspect as works of art, by their accent of intensified sincerity, as strange stories may carry conviction if a certain note is heard in the voice of him who tells them.

There are three figure subjects. One a Taos Indian, lean and square-shouldered under heavy garments, peering keenly forward, the background some broadly checkered material, adjusted to give a diagonal movement to the composition playing against the counter diagonal of the stiffly held arms, all the directions in significant repetition or opposition, commonplace, real, hieratic, remote. Next, the figure of a young girl, narrow and long, seated on a narrow high-backed chair, a big hat too big for the head, the head too big for the pinched figure—Ramoncita. The third is a portrait of a man, emphatic in character and with a finely organized design—Loren Mozley.

There is a still-life, the beautiful poppies of a recent Carnegie exhibition on the one hand and on the other the acid gayety of "Christmas Fruit," green of verdigris, yellow or brass, artificial fruits of course, purely of decor, but taunting and almost puzzling with the reality of their unreality. . . . Long ago he developed an art answering bravely to the requirements of the French cubist, Fernand Léger, an art "precise, logical, simple, clear and definite." Today he has added to these primary qualities a surprisingly rich personal expressiveness, founded securely upon the same architectonic structure once too obvious in his paintings, but now almost merged in a result as humanly emotional as it is mathematically provable. In this result a rhythm, strong rather than subtle, not yet quite effortless in appearance, provides the bridge across which one may pass to the earlier work.[64]

After the show at the Rehn Galleries in 1928, Dasburg left Ida Rauh and, in December, married Nancy Lane, a talented actress who was active in politics. Her father was a San Francisco lawyer who had served under President Wilson as the country's first secretary of the interior. The bride and groom spent a four-month honeymoon in Puerto Rico. From the standpoint of an artist, the island turned out to be rewarding territory. In an oil painting in his mature style (fig. 41), Dasburg tightly condensed the cubes and rectangles of houses conveniently arranged in a ready-made geometric relationship against a hillside with the blue ocean below.

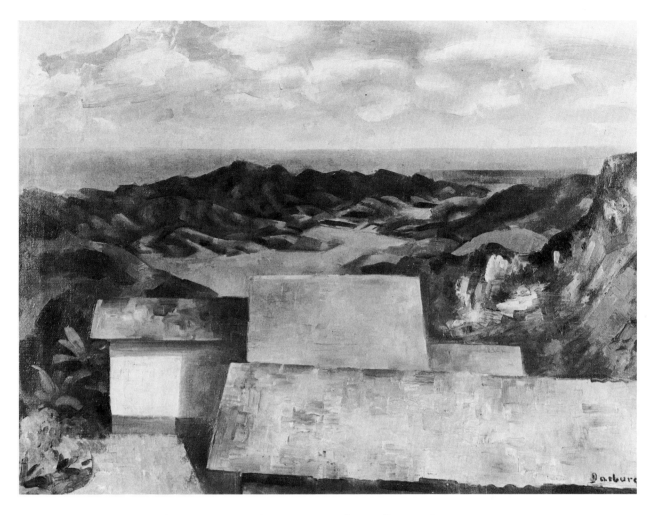

FIGURE 41. *Puerto Rican Plantation.* 1929. Oil, 15½ x 21½ inches. Collection of the University of New Mexico Art Museum, Albuquerque, N.M., gift of Edwin F. Gamble.

He also painted a number of watercolors and made some finished drawings of palm trees. The watercolors (fig. 42) were freely painted in broad pools of pink and mint green, reflecting the brilliant light and the local taste for brightly colored houses. There was no inventive daring to these paintings; rather they reflect the pleasures the artist was enjoying in the exotic tropics. The drawings of tops of palm trees, however, are quite different in character (fig. 43). The parts of the fronds and fruit posed challenging pictorial problems, for Dasburg had to work from an unusual

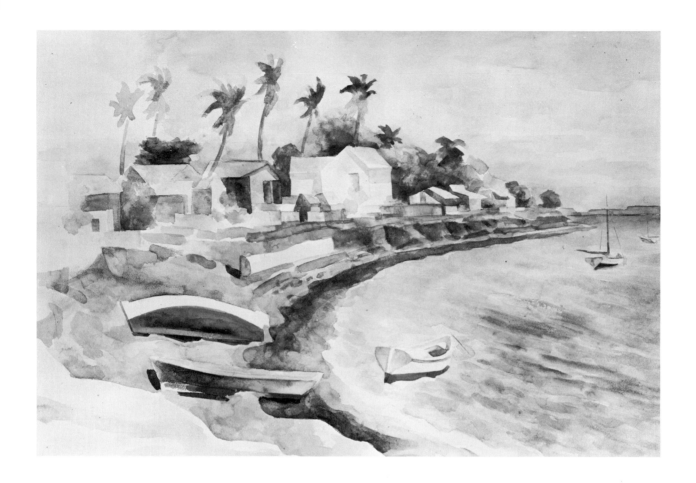

FIGURE 42. *Puerto Rican Beach.* 1929. Watercolor on paper, 13½ x 19¼ inches. Collection of the University of New Mexico Art Museum, Albuquerque, N.M.

perspective, looking slightly up at a nearby subject rather than working from a comfortable distance where the parts were more readily separated. There is nothing tentative about his pencil strokes. With a skill and fluency he had developed to take advantage of his analytical eye, the process of growth of the palm tree was indicated. That is, we see how the palm fronds grow out of the trunk of the tree in arcing forms, and we are made aware of the limits within which the fruit and reproductive parts of the tree fit the overall scheme. By reducing details and giving the forms a relatedness, he succinctly conveyed the essence of this new type of subject.

Upon their return from Puerto Rico in 1929 the Dasburgs made their home on an acre-and-a-half lot in Santa Fe on the Camino del Monte Sol, the

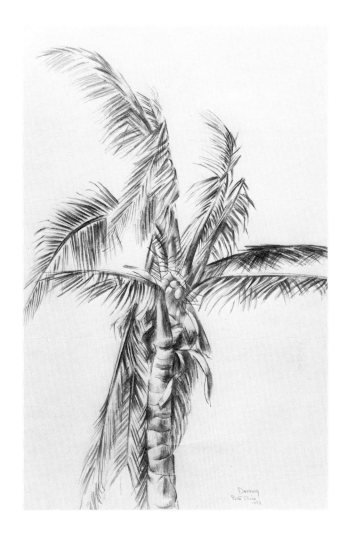

FIGURE 43. *Palm Tree.* 1929. Pencil on paper, 16 x 11½ inches. Collection of Mr. and Mrs. Gerald Peters, Santa Fe, N.M.

winding dirt road on the eastern edge of the city were a number of painters were already established. At first they camped out in a log cabin that was already on the property. Dasburg and the architect John Gaw Meem designed and supervised the building of an adobe house that cleverly incorporated the cabin as a bedroom and part of a studio. Here he had earlier painted *Road to Lamy,* now in the collection of the Metropolitan Museum of Art (fig. 44).

At about this time Dasburg was asked by Arthur Ficke to paint a portrait of his father (fig. 45). A portrait of one's son or a close friend or student is not quite the same thing as a commissioned portrait. A man of independent means, a patron of the arts, and a poet, Ficke knew Dasburg's work so well that he was prepared for the painter's somewhat static representation of his father, Charles Augustus

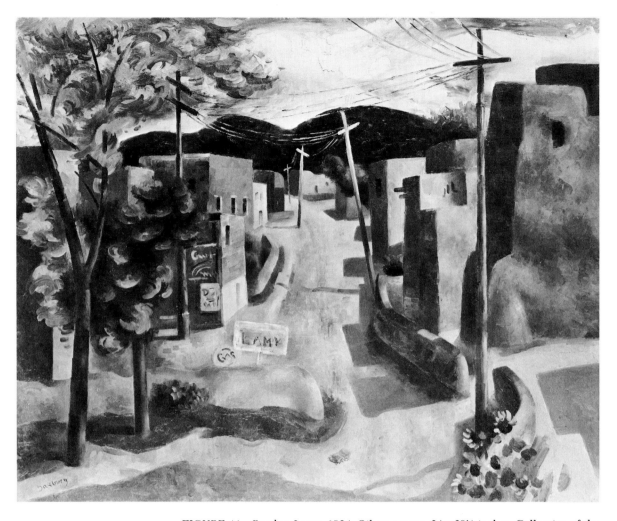

FIGURE 44. *Road to Lamy.* 1924. Oil on canvas, 24 x 29½ inches. Collection of the Metropolitan Museum of Art, New York, N.Y., George A. Hears Fund, 1951.

Ficke. Dasburg stressed the elongated frame of his subject and his distinctive facial features. A rather conservative business suit conveyed something of the man's personality and his status. Apart from these characteristics Dasburg constructed this portrait very much as he had the one of his son, Alfred. By means of joining slightly curved planes, which look as though they were made of stiff paper stuffed with some solid substance, he emphasized the geometric nature of the human form and the clothes. Allusions were certainly made to the individuality of the subject, but the final result is a combination of simple tubular and cubic shapes. Blocked in are the dented, pipelike sleeves of Ficke's coat and pants legs. The head looks like

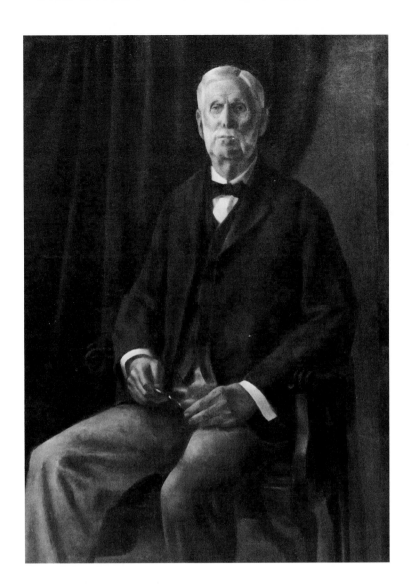

FIGURE 45. *Portrait of Charles Augustus Ficke.* C. 1928. Oil on canvas, 50 x 36 inches. Collection of the Fine Arts Museum, Museum of New Mexico, Santa Fe, N.M.

an egg. The figure is compressed within a relatively shallow space. Like Dasburg's other portraits, this is not a character study but an analysis of the visual relationships of forms. In this case, the result is also a rather successful translation into pictorial terms of the appearance of the subject of the picture.

Like so many people, Arthur Ficke became very fond of Dasburg. One day he said to him. "U.S. Steel is selling at a profit; I will buy 100 shares and give you the proceeds."[65] Ficke made a good profit on the investment, and true to his word, gave Dasburg a tidy sum. This looked to the painter like an easy way to make money—easier than painting portraits or selling Indian artifacts. Through a broker

in Denver he bought securities with all the money he had or could raise. In a short time he had run his investments up to a paper value of $100,000. As the market escalated, Dasburg, like so many others, lost his perspective. Just before the 1929 crash of the stock market he was advised by the father of his friend Cecil Clark to sell out, but rather than taking this advice he set off for the country to shoot canvasback ducks. By the time he returned to Santa Fe he had lost $40,000 of his paper profits. He felt the market would rally but in the crash of 1929 he lost all his own money and much of his wife's. Fortunately his mother-in-law held the mortgage on the house they had built, so they were able to retain it.

In addition to portraits, during the mid twenties Dasburg also painted a full-length nude (plate 12). He had drawn from nude models frequently, but rarely had he carried out a fully developed painting of this classic subject. The incorporation of his ideas about form into a painting of a handsome, reclining nude was not easy, but he triumphed over the difficulties presented by the subject. What he did was paint the figure so that it emerged out of the background as a somewhat decorous figure, only moderately erotic. There is a slight sense of quivering flesh, but more prominent is a feeling of full, smoothly rounded forms that flow one into another. In no sense does the painter seem to worship ideal beauty. He is firmly in control, within a framework dictated by his concern for analysis of forms, with only a hint of sensual lyricism. His primary interest is in reshaping nature to find new ways to treat even a subject with such a challenging history. The undulating rhythms he created in this picture celebrate the sensual quality of flesh as an abstraction rather than as a personalized characteristic. It is as if he were testing his sensations in the presence of a provocative model to see how consistent were his responses. The focus is sharp and the arrangement of the figure pleasing, yet we are impressed more by the ingenious way he has mastered the art of evoking so economically his subject's femininity. The restrictions he put upon himself would not seem to add up to a desirable Manetesque Olympia; but even as he solved the problems related to the figure, he conveyed his inner responses to this subject.

He limited the number of forms in his pictures like the nude to give a clearer understanding of their relationships. The distinction between a work of art and a work of nature was clear-cut in his mind. His treatment, as an artist, of the collection of forms that he observed in a motif, not the illustration of the original facts that he saw, gives his work a special and sober character. As far as recognizable forms are concerned he moves from the specific to the general in order to define his responses in terms of formal relationships. Thus an exceptional subject, such as a nude, can often be the starting point for a markedly individual

work with only nominal relations to the refinements incorporated in the actual subject.

In October 1930 some paintings Dasburg had done in New Mexico were included in a group show at New York's Rehn Galleries. A reviewer wrote, "His work is restrained and mature. One is struck by the 'tightness' of Dasburg's work. It is not lacking in vigor and spirited movement, but every stroke is made to count. Each composition holds together with remarkable firmness."

After 1930 Dasburg ceased to return to Woodstock and New York City in the summers. His wife wished to live in Santa Fe, and there was little money to travel about. His work could still be seen in New York City at the Rehn Galleries, but sales became fewer and fewer, owing to the depression that plagued the country throughout the thirties. Many artists in New Mexico and elsewhere suffered as patrons found themselves no longer able to afford paintings. Government programs such as the Public Works Project gave employment to many New Mexico artists, but Dasburg did not participate in any of them. Living modestly, he was able to survive by selling a few paintings and Indian artifacts.

The country was going through intellectual and emotional crises as well as financial ones during these lean years. Realism had always contended vigorously with modernism for attention and patronage; in the thirties it began to dominate, as pictures with social significance became popular. John Stuart Curry, Thomas Hart Benton, and Grant Wood led the movement toward subject matter from the heartland that embodied the romantic notion that life was better when lived close to the soil. The critic Thomas Craven gave credibility to these men's efforts to make an art out of anecdotes drawn from historical events, popular music, and life close to nature. Though Dasburg's mild modernism was not involved with anecdote, neither was it very abstract, and he frequently painted quite recognizable landscapes and still lifes. But rather than serve as a background for a story, his paintings were intended to call attention to forms in nature that he felt were able to convey the essence of the earth itself. He was admired by students for this and by a few fellow artists, but not by the general public.

In the first years of the thirties, Dasburg was busy getting his new house in order and finishing paintings for another one-man show at the Rehn Galleries. The pictures, largely of New Mexico subjects, were received favorably by the critics, but few were sold because of the country's depressed economic condition. Dasburg's spirits were buoyed, however, in 1931, when he received the Allegheny Garden Club Prize at the Carnegie International in Pittsburgh for his painting *Bouquet.* In 1932 he received another honor: he was awarded a John Simon

Guggenheim Fellowship to study and paint in Mexico. Mexican art had become the focus of a great deal of attention, owing largely to the paintings of José Clemente Orozco, Diego Rivera, and David Alfaro Siqueiros. Dasburg spent three months in Mexico, partly in Mexico City and partly in Taxco, where he had the use of a house belonging to Mabel Dodge Luhan's son, John Evans. The paintings he did in Mexico were more conservative in formal inventiveness than any he had done in recent years. This was possibly due to the change in locale, which he had to absorb, but may also have been due to the notion prevailing in Mexico that simplified forms, but not Cubist forms, should be used to make art easier for people to understand. Dasburg, who was politically conservative but, to a degree, artistically radical, discussed the political climate there with Rivera and the other artists he met. Rivera had been a very accomplished Cubist painter working in Paris before World War I, but when the Mexican Revolution started he returned home and became a painter of historic events and vignettes of working people in a style marked by graphic emphasis rather than formal innovation. Unlike Dasburg, he was a revolutionary who painted in a conservative style. Rivera had a predilection for compact compositions of figures seen as symbols of politically oppressed people who by virtue of their peasant strength had survived to form a new order. Dasburg seems to have been more impressed by Rivera's sweeping draughtsmanship than by his subject matter.

One of the few outstanding pictures Dasburg painted in Mexico was *Taxco* (color plate 13). Its swirling lines and wide range of colors, from warm to hot, convey the spirit of that beautiful town, on the side of a mountain full of silver located southwest of Mexico City. The chopped-off corners remind us of Marin's framing devices, but the flow of forms is unquestionably Dasburg's.

At this time in his career we can see a change in Dasburg's style. The landscapes he had painted in the twenties (color plate 14) exposed each blocky house, molded as if from cast iron, so as to give a maximum sense of mass. By 1933, he had developed a new, entirely different landscape vision. The dominant forms in his new landscapes were clusters of sweeping curved lines or bent bands of watercolor pigment (figs. 46–48). Watercolor, a fluid medium, demands decisiveness; it must be set down in a short period of time to be fresh and vital. Dasburg's oils had always been carefully developed over a fairly long span of time. Color and even shapes, when painted in oils, were altered and orchestrated to achieve a careful balance of the various parts of a composition. This was not possible with watercolors.

FIGURE 46. *Afternoon, New Mexico.* C. 1933. Watercolor on paper, 14⅜ x 21½ inches. Collection of the Santa Barbara Museum of Art, Santa Barbara, Calif., gift of Mr. and Mrs. Dalzell Hatfield.

FIGURE 47. *Landscape.* 1933. Watercolor on paper, 14¾ x 21½ inches. Collection of the University of New Mexico Art Museum, Albuquerque, N.M.

FIGURE 48. *November, New Mexico.* 1933. Watercolor on paper, 15 x 22 inches. Collection of the Dallas Museum of Fine Arts, Dallas, Tex., Dallas Art Association purchase.

Dasburg's switch to watercolor probably was due in part to the fact that John Marin spent the summers of 1931 and 1932 in Taos, as the guest of Mabel Dodge Luhan. Dasburg had known Marin in New York through his connections with Stieglitz. The two old acquaintances shared an interest not only in avant-garde art but in trout fishing as well. They often spent the day painting and fishing in the mountains and valleys near Taos. Marin was working only in watercolors and in all probability encouraged Dasburg to do likewise. Both Marin and Dasburg had seen Cézanne's work in Paris and had followed closely the development of Cubism but had taken from these experiences quite different messages. Marin's splintered cubistic style and vignetted corners seem to have had some effect on Dasburg, but they decidedly influenced the style of Dasburg's former student Ward Lockwood, who would frequently join the two men on fishing trips.

FIGURE 49. Andrew Dasburg in a comic
pose, 1932. Photograph by Will Connell.
Courtesy of the Museum of New Mexico, Santa
Fe, New Mexico.

Ward Lockwood told a story that is deeply revealing of Dasburg's way of
accomplishing whatever tasks he set himself. While unsuccessfuly fly fishing for
trout, Dasburg turned to Lockwood and said, "I can't understand it. I have
imagined every move that *I* would make *if I were that trout* and still he won't take
the hook." Lockwood commented astutely:

> This incident and the remark, made half in desperation, half in
> humor, reveals some of Andrew's character. For one thing he possesses
> determination to an extraordinary degree—which is to say that he can on
> occasion be downright stubborn. To effectively oppose him at such times
> one might as well be a mushroom in the path of a bulldozer. It also
> illustrates another trait: He was attempting to transfer himself into the
> object of his rapt attention. This he does when painting a landscape. He

becomes the landscape and it becomes him. Together they shift, alter, grow, and become fused in the complex of form, space and color that is the painting. On the part of the artist in the creation of such a personal universe, immense patience, singleness of purpose, transplantation of the self, and a dogged determination amounting to stubbornness, become qualities of prime importance. I find in looking at his paintings that the landscapes (somber, calm, tumultuous or bright) and the still lifes (stark, joyful, mysterious or restrained) are reflections more of the mood of Andrew than that of the subject. His powerful personality is indelibly impressed on each. For, as he himself has said, art is a metaphor.[66]

The watercolors of the early thirties show that Dasburg was not completely locked into a system. His earlier New Mexico landscapes were rather airless; these watercolors, in contrast, speak directly of air currents and the effects of the moving air on the billowing summer clouds. The rather solemn mood of the twenties, a period of dignity and propriety in Dasburg's work, gave way to a feeling of unselfconsciousness that was quite a novelty. Nevertheless, the smoothly and firmly composed oils are in the long run much stronger than the somewhat fidgety and gestural watercolors. The oils are more assured. Their tight calculations are more natural for Dasburg, who has a distinct feel for the quality and luminosity of oil paint.

In general, precision seems preferable to velocity in Dasburg's work. But if we look ahead, as we can in a retrospective survey like this, we can see the new sweep in the 1930s watercolors as the imperfect beginning of the spare, pulsating, and dynamic drawings done in the 1960s and 1970s.

The new style of Dasburg's early 1930s landscapes reflected a change in his personal life. He divorced Nancy Lane in 1932 and the next year married Marina Wister, the daughter of Owen Wister, author of *The Virginian*, the classic Western novel and other popular books. The Wisters lived in Bryn Mawr, Pennsylvania. Miss Wister had met Dasburg in New Mexico, where she was collecting native artifacts for exhibition in Philadelphia. A poet who had published several volumes of verse, she had won the Browning Medal for her poem "The Sea."

At first when Dasburg and his wife returned to New Mexico from the East they lived in Llano Quemado outside of Taos; then they moved to one of Mabel Dodge Luhan's houses in Taos. Although she liked the area around Philadelphia, Marina realized that Dasburg was devoted to New Mexico and agreed that they would live in the vicinity of Taos. The road that ran east from Ranchos de Taos

toward the mountains, through the old community of Talpa, was improved in 1933. They found a place in 1935 on the Talpa ridge overlooking the beautiful valley through which a little river flowed. The place was acquired for $1,700—$100 per room in the two houses and $75 per acre. The smaller of the two houses, an adobe building located on the edge of the ridge, served as a studio. Soon they began to enlarge the other adobe building, located between two giant cottonwood trees. Dasburg virtually gave up painting to supervise the work on the house. In addition to planning the layout of the rooms, he laid the brick and tile floor and saw to all other aspects of construction of the house. This was a physically and emotionally taxing period in his life. He soon found that he was exhausted after even the slightest exertion.

At this time he received a commission from the trustees of the Colorado Springs Fine Arts Center. He and his former students Ward Lockwood and Kenneth Adams were to decorate the Center's theater lobby with murals. Dasburg was so weak, however, that his work was the last to be completed. He made a preliminary watercolor study in late 1936 and began work on the mural in early 1937, but in March he realized that he was desperately ill, and he had to be taken to Albuquerque to the hospital. Doctors were unable to diagnose his ailment until a recently graduated intern suggested that Dasburg had Addison's disease, a debilitating deficiency of the adrenal glands. Probably the disease was related to Dasburg's childhood tuberculosis of the hip, which he had not known he had but which was the reason his hip had not healed when he was injured as a boy.

In 1937 no cure for Addison's disease was known. Through friends in Philadelphia, Mrs. Dasburg learned that Dr. Leonard Roundtree was using Swingle's adrenal extract, developed by a biologist at Princeton University, to keep sufferers from Addison's disease alive. A supply of this extract was sent to Albuquerque and administered daily to prevent further deterioration of Dasburg's energy. He was then taken to Pennsylvania, to be nursed at the Wisters' home. The adrenal extract saved Dasburg's life, and by the middle of the year he was getting about and was back at painting. A watercolor of railroad tracks and large storage tanks painted near Philadelphia has survived. He felt cooped up in his in-laws' home, and late in the summer he returned to Taos. Although still weak, he finished the mural for the Colorado Springs Fine Arts Center; it was installed by the end of 1937 (fig. 50). The subject of this painting was prophetic: it showed figures performing feats of strength and deception. In the long panel can be seen played out the problem all of us have to overcome, that is, inertia brought on by the mind and by gravity. A juggler, a strong man with weights, a woman balancing on her

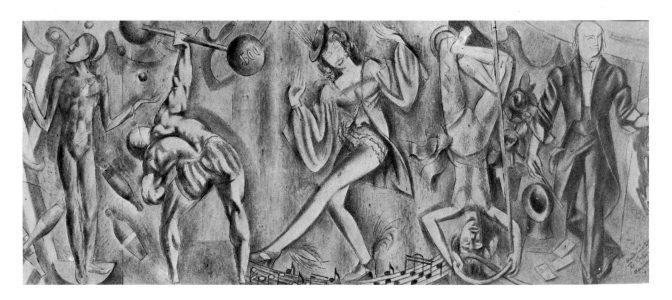

FIGURE 50. *Untitled* (mural). 1937. True fresco, 58 x 150 inches. Colorado Springs Fine Arts Center, Colorado Springs, Colo.

head, and a man performing sleight-of-hand tricks all exemplify the idea of seemingly effortless grace when performing. These figures were conceived as symbols of the disciplines needed to defy human weakness while bringing order and beauty to the world.

Today, this work would not be considered among the artist's strongest paintings, but it is more indicative, in pictorial terms, than many other things we could study of the man as an emotional/intellectual being. The artist was transforming his inner struggle into an art form for this work. It was done under considerable difficulty of body as well as mind. Mabel saw the mural in Taos before it was dispatched to Colorado Springs and wrote a most glowing response to Dasburg, speaking both of the work and of the fortitude of the artist. Her letter gives us a feeling of her continuing fondness for Dasburg as a person and respect for him as an artist. She wrote:

> I have to write you a line to tell you how moved & thrilled I was yesterday when I saw the decoration. I believe that I, who have known your work so well, & for such a long time can really appreciate the significance of this last production. To find that you have arrived at a maturity of idea & execution in the year of a severe illness, & that you have made a sudden advance over the previous years, is so encouraging

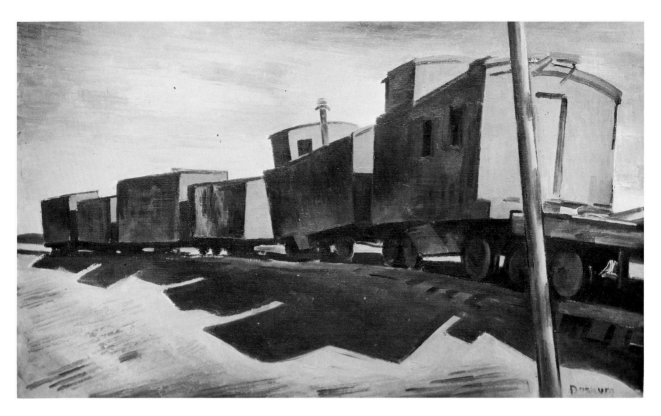

FIGURE 51. *Freight Train.* 1933. Oil. Formerly in the collection of Thornton Wilder. Present whereabouts unknown.

for everyone who might feel a middle-age cessation of the urge to work & create! You are so much an artist, though, that you have actually utilised the major problem of your age, situation, & physiological-psychological difficulties, & in that way have produced the most mature & expressive work you have ever done! During the immediately previous years there has been a sort of lull in your creativeness that was not heartening though it was expressed too, just as though even the pause of the flow of life may turn, for an artist, into artistic content. For instance in the painting that Thornton Wilder bought & that appealed to him, I believe, because it somehow described to him his own temporary predicament, you consciously or not were presenting the most perfect picture of middle-aged cessation & the end of usefulness of energy. [See fig. 51.] That old freight-train fading, side tracked, no longer moving, no longer able to carry its load, drying up, abandoned! How extremely *expressed* that was!

How familiar, daily, tragic, *that* situation is to people! And alas, how seldom overcome. It is the more frequent happening when people stop in their middle years & feel they have done all they are able to do. But when there is enough sap & energy left, enough of the divine urge to go on—then that rare thing happens that I saw yesterday, & the artist triumphs over the man & the beautiful rebirth takes place—where he arrived at a real maturity. I really believe that the mature work of any artist only comes if he survives the terrible pause of his energy in the middle years. Up to that time he is more or less an apprentice to his function, after it if he gets through it, he is the deux ex machina. If it is true that "life begins at forty" it is more true that great art begins at fifty. I have always believed this & you are another corroboration of it.

And I really laughed with excitement & glee all the way home at the way you had actually presented a picture of yourself overcoming the inertias that beset you—& doing it with the apparently careless ease & nonchalance of a true juggler! Yet, as we know the terrible effort & concentration it has cost the juggler & acrobat to arrive at his playful & poetic accuracy, so I knew what over-coming you had experienced to show the juggler in his success. What a wonderful faculty there is in man—to so transform & use his inevitable earthly experiences! It restores again one's belief in the artist—a belief I had lately lost—having grown bored with Art & Artists because I forgot that one does not often see them in the Southwest, & that all these little people we do see are none of them engaged in the great struggle at all, but are mainly thinking of the minor issues—& are confused by financial needs & the tricks of ambition, & the naggings of their families. What do any one of them know about this marvelous faculty that only a man, of all living creatures, possesses, the faculty of transformation, in [Dr.] Brill's language of sublimation.

So this painting, whose color is finer than in any you have done before, & its technique more certain, is to me a sign that you have come through—that you have overcome the fatal inertias, & that your best work is being done. . . . & is still ahead of you, and to end up with a thought of myself (of course!) that if you have done it, why can't I also! So it is full of encouragement all round![67]

Mabel's encouragement notwithstanding, from 1938 to 1943 Dasburg did almost no creative work. Swingle's extract kept him alive but his energy was at

such a low ebb that he could hardly summon the physical or psychological energy to work in his studio.

During the years of his illness Dasburg destroyed a great deal of his work because he felt dissatisfied with what he'd done. It is impossible to tell how much work that others might have felt was significant ended up in a trash bin. One example is perhaps indicative of what has been lost. About ten years ago Dasburg's friend Earl Stroh found in a dusty cover of his former teacher's studio an oil painting rolled up in kraft paper. Stroh rolled out the canvas on the floor and was impressed by the quality of the picture, a portrait of a woman in a lovely oval hat. He asked Dasburg about the picture. He said he had forgotten about it and thought it should be destroyed because there were unsatisfactory passages in it that had always bothered him. Stroh took exception to this assessment and asked if he could clean off the surface dirt and restretch the painting. This he was permitted to do, and when he showed it again to Dasburg and commented that it was a truly fine painting and deserved a place in a good collection, the creator of the work conceded that it did have some very good qualities. It was framed and taken to the Mission Gallery in Taos to be sold. This painting, which was almost destroyed by Dasburg, is the *Portrait of Cecil* reproduced here in color (plate 9) now a valued example of Dasburg's work in the Denver Art Museum's collection. How many such pictures were destroyed is not known.

Antonia Mygatt (Lucas), who came to Taos in August 1943 in search of a new environment in which to live and paint, was introduced to Dasburg early in the fall.[68] He immediately took an interest in her work. At the time, she remembers, he was vigorous-looking but thin. He was doing a little painting and some drawings from nature but seemed to be spending a great deal of time just puttering around his studio. There were serious problems with his marriage. His wife would stay up all night and he was up in the daytime. When her father, Owen Wister, became seriously ill in Philadelphia, she left Taos to be near him; later she had a mental breakdown. She never returned to New Mexico. Toni, as Antonia was known to everyone, became Dasburg's companion. She was his student as well as his intimate friend and recalls well his comments about her paintings. Because these comments reflect his thinking about form and color and are indicators of his mental processes when painting and drawing, they are of particular interest. He would say of a painting that the weight on one side was too heavy to carry the whole picture and would often poke his cane at a part of one of her pictures and talk about the problem of balance in the overall weight of the image. When part of a picture was not fitting in with the overall composition, he liked to say, "When something

bothers you, always remember to look elsewhere for the trouble." In his house, she recalls, he was down in spirit and had to be waited upon. In the nearby studio, on the other hand, he was a different person, more alive and outgoing. It was the act of drawing or painting or the effort to solve pictorial problems that stimulated him physically and mentally. On warm days he enjoyed sitting on the ground in a sage-covered field at sunset. On such occasions he spoke little of the mystery of nature but much about the way forms could be simplified and placed in a picture and about the way light would define certain elements and change the shape of others. Formal construction was what he talked about. He would also sometimes talk to Toni about his "failure" as a painter of people, despite the numerous strong portraits he had painted and drawn. The fact that he could not help treating a person's face like a pear in a still life bothered him. He could not, he felt, sense people's personalities and put them down on canvas or paper.

In 1943, to celebrate his renewed strength, Dasburg took on a problem different from any he had tried to solve before. This was to paint a mandolin inlaid with light and dark wood, with five sprouting onions, spread out across a low table (plate 15). The neck and most of the body of the instrument can be seen resting below the wooden tabletop on which the onions, one of them in a bowl, sit as if waiting for something to happen. To give a feeling of vitality to the arrangement, Dasburg made full use of diagonals—nothing is parallel to the sides of the painting. The neck of the mandolin and the bulging inlaid stripes set up counter reverberations in the slightly off-horizontal edge of the table above the instrument and in a tentatively sketched-in wood stretcher between the tables legs below the mandolin. A triangular portion of what seems to be a narrow door or is possibly just a pictorial invention is seen behind the table leaning against the wall at an angle. This provides another diagonal. The top of the table tilts up a few degrees so as to set up tensions related to the pull of gravity and to give us a full, round look at each onion.

For a Dasburg, this painting is most unusual. Comprising precise and ordered parts, it nevertheless conveys a sense of overall uncertainty. Yet the thrusts of the diagonals as they play off one another are perfectly balanced. This painting eloquently shows how a skilled artist who is bored with a systematic solution to pictorial problems of balance can achieve a casual psychological balance of units—even though seemingly illogically placed in his composition. This picture shows the beginning of a new, looser paint handling and a greater clarity and lightness of color.

By the middle of 1944 Dasburg was feeling well enough to undertake another serious painting (plate 16). He arranged on a plain tabletop fourteen spherical forms—a head of purple cabbage, two green pepper, and some apples, pears, and pomegranates. Using only a few realistic details, he rendered them in a style reminiscent of his work of the 1920s. Defining the mass of the spheres in an uncompromising fashion was his major aim. The curved exteriors of the various fruits and vegetables were arranged to create a rhythm across the table. The various colors provide a cadence for the overall motif. There is no evidence of a feeling of hesitancy as Dasburg reclaims his mastery as a painter. His special insight into the forms' structure is quite evident as he fixes our attention on the similarities as well as the differences among the elements. We can sense the soft geometry of the fruits and vegetables as well as the manner in which the assembled forms have been carefully placed within the frame of the tilted Cézannesque tabletop.

In the late 1940s and early 1950s, Dasburg had a period of depression. His health was not good, his pictures were not selling, and he was producing very little except ink drawings. As has often been the case throughout his life, champions helped in a number of ways to foster his art and bolster his spirits. A letter written by Edward Gamble of Boston, who had studied with Dasburg in New Mexico, throws light on this period. Aware of Dasburg's feeling of depression, Gamble acted as an unpaid agent and took *Road to Lamy* (1924) to Robert Beverly Hale, curator of American art at the Metropolitan Museum. He strongly urged that the museum acquire this Dasburg canvas (fig. 44). Hale was interested and accepted the tentative price of $1,200, though he informed Gamble that a selection committee must make the final decision about any acquisition. After delivering the painting to the Metropolitan, Gamble took the remainder of the pictures in his hands to the Whitney Museum. He wrote to Dasburg:

> Mr. Moore expressed a desire to buy the "Ranchos Road" at $600—and to trade an early still life of yours for the "Bakos." If this is acceptable with you, I will do this. Trading, contrary to my earlier conceptions, is highly acceptable. In this case I strongly recommend it. It will represent you with a better picture at the Whitney and in exchange provide Bertha Schaefer [a prominent dealer in New York] with exactly the type of picture she wants for Midwestern Universities. *Please write me immediately how to proceed in this matter*—as the Whitney buying committee meets December 18th.

The still life in question was originally sold to the Whitney in the 20's for $500—or $600—according to Mr. Moore. Its size is 16″ x 20″ and titled "More Fruit."

Gamble's closing remarks are indicative of Dasburg's low state of mind:

> There are volumes to tell you of the tremendous stimulus of New York life. Would that you too could receive all these galvanic impulses. Then *I know your painting would again come to life.*[69]

While this time in his career was not his most productive period, Dasburg was still an effective teacher and thinker. Earl Stroh was a major post–World War II student of his who has maintained a close personal and professional relationship with Dasburg in Taos. He first became acquainted with his teacher's work in 1947, when he came to Albuquerque to study art at the University of New Mexico. During a Department of Art summer session in Taos, Dasburg was a visiting critic. Stroh recalls his reaction to Dasburg's comments about the work of the students: "I was, like many of the other students, struck with his insight into the problem of painting. It was immediately obvious that here was an artist interested in your work, in your possibilities and sensibilities and not just in passing on his methods or style. . . . I arranged to return to Taos the following summer to work with him privately."[70]

How did he teach? Usually by metaphorical commentary on a specific problem in a painting. Charles Kassler wrote some of his teacher's comments in a notebook while he was studying with Dasburg: "Pictorially considered, nature is never right." "Without a certain amount of artificiality, there can be no art." Dasburg would often refer to such artists as Mondrian and Picasso when speaking of composition.[71]

Mabel Dodge Luhan once said, "From the early years of his career Dasburg had a curious power over other artists. It almost seemed he had a magic hand that drew from the student the potential creativeness that so often is unawakened and lies dormant a whole life through. He was able to communicate his own gift of seeing and stimulate in others the faculty so strongly developed in himself. He was really, from the first, a born teacher, and many recognized painters owe him a great deal."

In addition to commenting on technique to his students, Dasburg often wrote in very discerning terms of color, weather, and the effects of light in letters to his

102

PLATE 13. *Taxco*. 1932. Watercolor on paper, 14 x 21 inches. Collection of Fritz Scholder, Galisteo, N.M.

PLATE 14. *New Mexican Village.* 1926. Oil on canvas, 24 x 30 inches. Collection of the
Fine Arts Museum, Museum of New Mexico, Santa Fe, N.M.

PLATE 15. *Still Life with Mandolin and Vegetables.* 1947. Oil on canvas, 22 x 26 inches. Collection of Mr. and Mrs. Gerald Peters, Santa Fe, N.M.

PLATE 16. *Still Life.* 1944. Oil on canvas, 20 x 24 inches. Collection of the Wheelwright Museum of the American Indian, Santa Fe, N.M.

family and friends. Exemplifying his more formal comments on the subject of art criticism in general is an article published in 1951 in the *New Mexico Quarterly*.

> Technique in painting (unless it be the chemistry of color) is not something to be learned apart from content. The nature of a concept will determine to an extent the form it is to assume.
>
> During the past forty years or more, a change of emphasis has taken place in painting from a narrative and illusional form to a boldly decorative and enigmatic one. Color, the medium of painting, is no longer made subservient to imitating effects, but is stressed as an end in itself. A picture is again intended to be an object of beauty in its own right and not merely a window to a make-believe world. In many instances the artist has abandoned worldly objects entirely or transformed them into new unities. To ask him to slavishly accept natural phenomena would be to deny him freedom of expression. Nature is not art, and is impossible to use without its undergoing change.
>
> No human eye has ever seen the whole of a grain of sand in a glance. Everything we look at gives us but a partial and distorted view of itself. There is a vast distinction between what we know of an object and what we can see of it at any moment. A large section always remains hidden from our sight. In painting, however, its total form can be effectively implied.
>
> The ancient Chinese painters, who were more philosophically minded than some of our "Realists," extended the boundaries of common experience through the happy union of the essential norm of things with the true proportion of one image in relation to another.
>
> The truth of the visible world resides in us.[72]

The year following the publication of this statement started off well, as a new period of energy for Dasburg. He concentrated largely on ink drawings but also executed pastels and casein gouaches. The watercolors *Autumn Desert* and *White Morning* of 1952 and the drawings of the same year, *Sage and Piñons* (fig. 52) and *Easter Morning* (fig. 53) are outstanding and indicative of the freedom with which he was working at the time.

Late in 1952, however, Dasburg had a mild stroke and was ill for over a year. Toni moved into his house and cared for him, since his wife had not returned to Taos. For a while he could not paint at all, but he soon found enough strength to

FIGURE 52. *Sage and Piñons.* 1952. Ink on paper, 15¾ x 20 inches. Collection of Mr. and Mrs. Ted Egri, Taos, N.M.

FIGURE 53. *Easter Morning.* 1952. Ink on paper, 17 x 22 inches. Private collection, Taos, N.M.

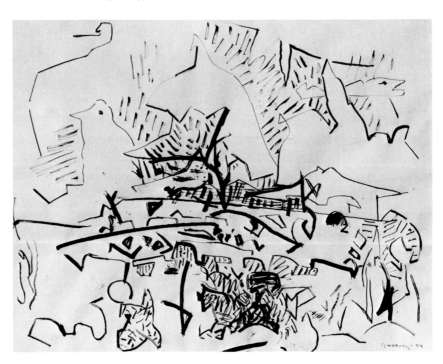

walk the hundred feet from the house to his studio. To get him going again, Toni encouraged him to undertake a complex painting. It was hard work for both of them, for the picture just would not come together. Toni recalls that despite the debilitating effect of the stroke, he doggedly kept at the painting each day. She feels that this crisis gave him the strength to continue his life, and that what has happened in his work over the last twenty-five years evolved psychologically out of these very trying months.

The late fifties were a crucial point in his career. After helping him through his illness, Toni left Dasburg in 1957. Fortunately at this time he was given new recognition. In 1959 the American Federation of Arts, under a grant from the Ford Foundation Program in the Humanities and the Arts, circulated across the country a limited retrospective exhibition of thirty-seven of his paintings and drawings from the period 1918–58. This exhibition indicates that Dasburg became very productive in the fifties after his long period of weariness of body and mind brought on by Addison's disease. The drawings he produced during the 1950s show a new freedom and dynamism, particularly in their use of line.

It may be useful here to recall what Dasburg wrote in 1923: "The objects and occurrences of natural phenomena are not art. . . . for [the artist] not appearances, but causations—the underlying geometric mechanism—is the guiding principle on which he builds."[73] Line became the most effective means for Dasburg to articulate his quest for this "underlying geometric mechanism" of nature, and nowhere is this more apparent than in the dynamic drawings he has made since World War II.[74] In the context of his career these seem to have been an inevitable outgrowth of the combination of his academic training, profound study of nature, and special brand of intuition.

In the late teens and twenties, as we have seen, Dasburg would return to Woodstock for the summer after a winter in New Mexico. There he made a number of finished drawings of the well-kept greenery and neatly disposed houses and barns of upstate New York. These drawings, of which *Rock City* (fig. 54) is an early example, are "cubic" in nature but no longer Cubistic. They were not intended as studies for paintings. In fact, Dasburg has rarely made finished studies for his paintings in the Renaissance manner, but he did make sketches in New Mexico which were the basis for paintings executed in Woodstock. Each medium has remained an independent means of expression, related but separate. His landscape, figure, and still-life drawings of the 1920s and 1930s frequently had a blocked-out formality that related Dasburg to his friend and follower Henry Lee McFee, and to other Americans who borrowed from Cubism but modified the

FIGURE 54. *Rock City.* C. 1918. Pencil on paper, 10½ x 16½ inches. Collection of Eleanor and Van Deren Coke, Albuquerque, N.M.

mannerisms to suit their own personalities. Influenced as much by Cézanne's concepts of form and ways to evoke a sense of deep space as by Cubism, they directed their attention to the fundamental geometric qualities inherent in their subjects. Dasburg made a number of drawings built up of carefully shaded pencil lines designed to produce the maximum effect of palpable density during the 1920s and 1930s (figs. 55, 56). He used the effect of sharp, cutting light to reveal the sheer physical reality and compactness of a house, tree, or potted plant. Dasburg rephrased what his eyes saw into an ordered, logical format that was intended to give the viewer a more complete knowledge of the inherent architecture of his motifs.

In 1932, when Dasburg went to Mexico, he did a number of figure drawings from memory that have something of the fullness of form associated with much of

FIGURE 55. *Stockbridge*. C. 1932. Charcoal and red chalk on paper, 32½ x 20⅛ inches. Private collection, Taos, N.M.

FIGURE 56. *Tulips*. 1934. Crayon on paper, 24 x 17⅞ inches. Collection of the Whitney Museum of American Art, New York, N.Y.

twentieth-century Mexican art. But Dasburg used line alone to achieve a specific rather than a generalized quality. The stereotyped, rounded figures of Rivera seem to come from a single mold; Dasburg's plastic effects, however, varied. They were usually achieved through a compact line accented by deviations that interrupted and enlivened the contours of a figure. Both artists eliminated nonessentials and concentrated on arching gestures, but Rivera's depended more upon a heavy pliant line, while Dasburg's retained something of his earlier disciplined reticence. From Rivera's drawings, one might assume that Mexico is a very breezy country, for his Indians are often covered with garments that billow out from their bodies like sails in the wind, thus deemphasizing the true nature of the form underneath. Dasburg's drawings, while lacking some of the Mexican artist's sweeping linear power, have more vitality and give a truer sense of the human form, owing to his juxtaposition of occasional angular passages with his curved strokes.

During the mid thirties, in addition to these figure drawings, Dasburg did a few landscapes in pencil that serve as a bridge between his early classically composed work and the late zestfully executed compositions. These drawings were still tonal in concept, but the light and dark portions mingled with sweeping strokes to arouse the viewer's awareness of such elements as dust, wind, and fleeting clouds. The artist represented these occurrences as bodily things and interlaced them with more strictly defined rocks and rolling hills set off against a backdrop of distant mountains. The viewer accepts Dasburg's poetic inventions in these pictures as being logical because of the absorbing way the eddying forms unify the environment.

In the 1940s, when he was able to lead an active life after his five-year bout with Addison's disease, he began to display a new strength as a draftsman. For the first time, he crisscrossed paper with a succession of broken space-making ellipses that, although not polished or filled out, conveyed a sense of power by outline alone (fig. 57). There was nothing precious or finicky about those deep black lines, darting and turning in a free but still distinctly summarizing manner. Through such strokes one could feel the physical gesture of the artist's hand as he crystallized his reactions to a scene or person.

Beginning in 1951, Dasburg began to reach out and take risks as he never had done before. His landscape drawings from that year on show a decided change in style (see fig. 58). He arrived at the distribution of forms as much by intuition as by calculated design. These pictures have none of the elegant modeling or high degree of finish found in most of his earlier work. Instead he used a stripped-down vocabulary to stand for clouds and hills. Strokes flowed uninterruptedly from one

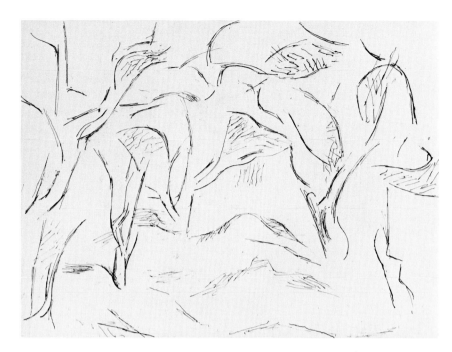

FIGURE 57. *Orchard*. 1950. Ink on paper, 14 x 19 inches. Collection of the Helene Wurlitzer Foundation of New Mexico, Taos, N.M.

FIGURE 58. *Pueblo Mountain*. 1953. India ink on paper, 15 x 19½ inches. Collection of the University of Nebraska Art Galleries, Lincoln, Nebr.

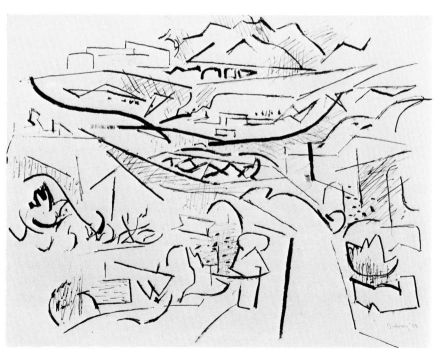

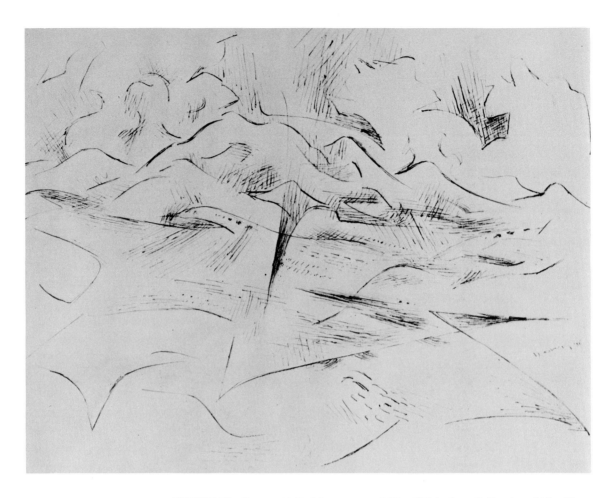

FIGURE 59. *Picuris.* 1948. Ink on paper, 16½ x 21½ inches. Collection of Mrs. Rose Woodall Waters, Taos, N.M.

part of the picture to another, then intertwined with a flurry of short, choppy lines to represent various details of the landscape. More and more he became involved with various ways of uniting sky and earth pictorially. In one instance he used what could be taken for a diablo, a miniature funnellike dust cloud, to connect the mountains with the plains below (fig. 59). By varying the width of his roughly sheared strokes and abruptly changing their direction, he guided the viewer to an awareness of the mysterious primordial forces that originally formed New Mexico's land and produced the vast mesas and sawtooth mountains found in the region.

Dasburg has until very recently worked directly from nature, whether from a figure, a still life, or a landscape motif (see figs. 60 and 61, recognizably showing

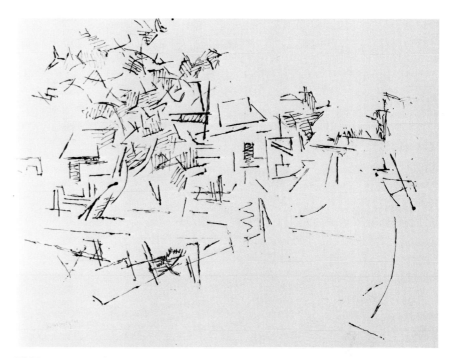

FIGURE 60. *Talpa.* 1961. Ink on paper, 17 x 22 inches. Collection of Rosamaria Ellis, Llano Quemado, N.M.

FIGURE 61. *Building with Trees.* 1961. Ink on paper, 17 x 23 inches. Collection of the Roswell Museum and Art Center, Roswell, N.M., gift of Mr. and Mrs. Howard Cook.

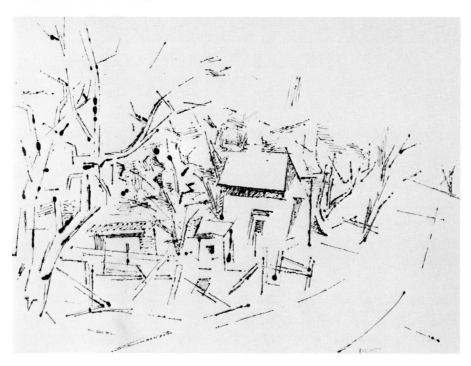

FIGURE 62. Dasburg, 1965. Photograph by Van Deren Coke.

the same locale). In the studio, he may alter or add elements to his drawings in order to engender his special brand of spare truthfulness, but the "set" of a drawing comes from firsthand observation. At times he seeks out a specific arrangement of trees or adobe buildings to serve as a starting point for a pictorial concept that occurred to him while reading or resting at home. More often he drives along one of the winding dirt roads that snake through the adobe villages or across the foothills of the Sangre de Cristo Range until he finds a situation that arrests his attention and seems to have potential as a subject for an interesting drawing.

Here he stops his car, rests his drawing board against his knees, and begins to

FIGURE 63. *Sage Flats, West.* 1961. Ink on paper, 16¾ x 21¾ inches. Collection of the University of New Mexico Art Museum, Albuquerque, N.M.

analyze the scene until he has deciphered its basic structural arrangement, with particular reference to related planes and contours. A visual inventory is made of the uprights and the horizontal geometry of a motif. He then measures with his eyes the degree of balance and imbalance he feels would be appropriate for that particular composition. Rhythmic dynamics, not exactness of representation, are his aim. As his eye gradually separates the predominant forms from the multiplicity of details and diversity of shapes, his pen or pencil begins to move steadily back and forth across the white sheet of paper. First he jots down something of the underlying armature of a scene in his bold, cursive manner. Indications of the main pattern of light and dark then bow to the ordering process

of the artist. It is almost as if he is participating in the design process of nature itself. Rarely does he resort to conventional chiaroscuro to indicate light and shade. What he does is make the white of the paper serve as both light and space as it appears behind and between his delicate and irregular network of pencil- or pen-drawn outlines. This endows his imagery with a feeling of expanding distance, a true characteristic of the crystal-clear atmosphere found in New Mexico.

The fact that everything is set down in what appears to be a series of brisk, restless gestures does not mean that Dasburg no longer arranges his forms purposefully. Today his compositions are more open and he takes a certain degree of license with nature, but his lifelong concern with order is still a subtle part of any arrangement. While certain dislocations may be incorporated in a drawing for aesthetic purposes, one can usually decode the constituent parts of a composition and locate the spot where the artist made a drawing. Generally retained are the basic reference points or linear accents of a scene. As he augments or alters subordinate shapes to create a harmonious arrangement, he soon evokes the essence of a place. To be sure that he has caught the true feeling of a locale, he may sketch two or three versions of a scene.

If one can say that his pre–World War II drawings were carved with a penknife and carefully sanded to achieve a correctness of volumetric proportions, it would be correct to characterize his work of the fifties and sixties as having been hacked out with an axe and left in a raw state that is starkly immediate and marvelously expressive.

In the early seventies his outlines became freer without the loss of any feeling of solidity in his shapes. He modeled with thin, active strokes that were whisked across the paper to describe a series of canted rooflines or to define the slopes of a hill. Welded together by a combination of clustered lines were the immediate foreground and distant clouds, so that the total arrangement was tilted up and flattened—a procedure often used by Cézanne. Dasburg has usually avoided recessional lines and adjusted his compositions so that a viewer cannot predict what will be found as he traces a retreating ink stroke or confluence of lines.

The subjects selected by Dasburg in the 1970s as the bases for his drawings are usually undramatic views of simple rural settings. In themselves they do not seem to have qualities that would provoke the term *dynamic*. Nevertheless, when the artist summarizes his responses to a string of earth-walled buildings or a clump of cottonwoods, the fundamental origins of these things are conveyed to us. At the same time, he refreshes our interest in such simple objects by playing one line against another to create dissonances of form that stimulate our attention like pinpricks. We look again and again at his drawings and each time find the

FIGURE 64. *Cottonwoods.* 1964. Ink on paper, 13 x 21 inches. Collection of Eleanor and Van Deren Coke, Albuquerque, N.M.

experience different and rewarding. Our attention is provoked by the way his straight pen and pencil lines break and the curved portions arc to form arabesques that describe the familiar landmarks of the region without involving the artist or viewer in a game of make-believe. Dasburg's sense of the setting is always strong, as is his interpretation of specific characteristics, such as the way the dazzling southwestern light filters through the perforated screen of leaves and limbs to create lively patterns on the edge of the roads and beside the low adobe structures of Llano Quemado and Ranchos de Taos.

It is interesting to note that all of Dasburg's landscape drawings are devoid of people. Nevertheless, life is present: it is implied by the orderly way in which trees

115

flank the fields and by the artist's frequent inclusion of the suggestion of a house or a row of fenceposts.

We also find that he uses different means to show different physical characteristics. The immovable quality of a wall or building is often underscored by making heavy, boxlike, or inverted L-shaped configurations. In order to register their capacity to twist and turn in the wind, he will indicate a group of trees with sketchy, loosely woven lines. Dasburg governs his repertory of lines not only to differentiate between forms of separate orders but also to confer upon his drawings a cadence, a lively abstract quality, that is distinctly rewarding to those who seek more than description in art.

While an observer's pleasure does not hinge upon his ability to recognize the source of Dasburg's imagery, ample identification of a subject is certainly one of the artist's intentions. Although elements of nature are left relatively intact, he creates a feeling of excitement in another dimension by reducing space and form to a free range of lines that captivate as much by their innate tempo as by the way particular properties of the region are portrayed. Dasburg's drawings always provide the viewer with an opportunity to participate in the process of creation. One is made aware of the semiabstract means he uses to stand for observed reality, but the charm of his vision lies in the fact that there is no tightly fitting import to the forms that enumerate the characteristics of his motifs. This is one of the ways he has solved the problem of representing the overworked New Mexico motifs used by many other artists without lapsing into sentimentality or superficiality.

Much can be learned of Dasburg's change of direction in the post–World War II years by comparing his 1939 drawing of Joe Mondragón with a likeness of Antonio Vigil done two decades later (figs. 65, 66). In the former, a beautifully rendered pencil drawing, the artist carefully shaded the smooth, rounded portions of the face and hat to give them a sense of substance. Emphasis was placed on the geometry beneath the man's features and attention was called to the strong axial alignment along the ridge of his nose. This element was countered by the lines which indicate the eyelids and the upper part of the lips. The effect conveyed is one of a pleasing formal clarity of shapes whose balance, weight, and volume make up the individual's personal characteristics. The head of Antonio Vigil, drawn in the 1950s, is quite different. Other and freer means were used to interpret and project some of the subject's underlying qualities. As Dasburg drew this elderly man, he was less concerned with refashioning the topography of his features than with creating a generalized impression of the many elderly Spanish Americans he has known during his fifty years of residence in New Mexico. This he achieved

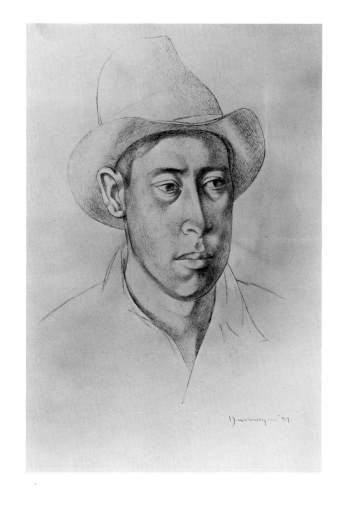

FIGURE 65. *Joe Mondragón.* 1939. Pencil on paper, 20 x 15 inches. Collection of the University of New Mexico Art Museum, Albuquerque, N.M.

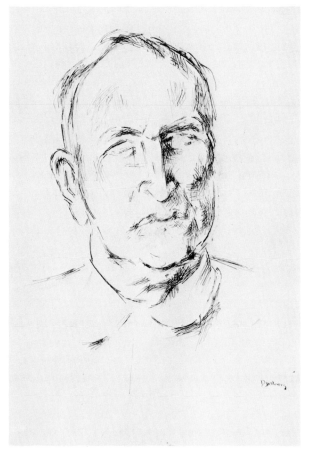

FIGURE 66. *Antonio Vigil.* C. 1960. Ink on paper, 20¾ x 17 inches. Collection of Hannah S. Gillespie, Talpa, N.M.

through the use of incisive accents and freely drawn, entangled strokes. What appears to be a spontaneous improvisation lacking in amplification is in fact a convincing statement of the man's "presence." On a sparingly modeled form, the neutral ground and the head were united, so that our eyes are allowed to travel freely through and around the various parts of the body without reducing the sense of tangible weightiness. What Dasburg had discovered was that a discontinuous line can define and convey materiality without necessarily becoming explicit or detailed. In comparison with the early drawing, this discovery led to a new breadth of feeling that penetrated beyond the visible surface. A more mature and introspective artist executed the later drawing. Such a drawing could only stem from an artist's innate rapport with a people and an environment. The terms he uses to express his feelings seem at first to be very simple; they conceal the skill that has brought him to such a marked degree of gestural freedom. Our respect is earned by the way he has invested his pictorial shorthand with great vitality while imparting something of the particular flavor of the subjects he selected.

Dasburg's drawings evoke memories of primitive Indian pictographs and some types of Indian pottery decoration. While his allusions to such forms may be totally unconscious, it is a fact that Dasburg has a considerable knowledge of and respect for Indian traditions. Consciously, he intends to create an equivalent expression to that which he experienced during the process of arranging his notations on paper. Just as we grow to appreciate the designs in Indian art, we can become attuned to his restrained stylizations of nature. It is evident that his drawings are not made to provoke sentiment or to be stimulating the way design patterns usually are. His intentions are more forthright. What he does is eliminate all unnecessary details so that an ensemble of jotted lines can faithfully tell us what he has found essential in a motif. While readily connected with what one can observe, the forms he emphasizes generally lack distinctness until Dasburg gives them his special kind of clarification. He conveys his special responses to a motif in abridged, but still concrete, terms, like notes on a sheet of music. He links emotion and the life of things into a single expression.

Space in New Mexico seems to be measured in celestial terms. Imaginatively, Dasburg deals with the formal and expressive problem of diagraming in his drawings this striking aspect of the Taos environment. Fractured but incisive strokes, by suggestive means alone, denote topographic shifts in the landscape as if they were deployed on a giant surveyor's map. When viewing some of his landscape drawings, one seems to be suspended in a dome above a vast sweep of countryside that spreads to the horizon. No longer do the laws of perspective and the pressure of gravity apply (see fig. 67).

FIGURE 67. *Untitled* (landscape). 1963. Ink on paper, 18½ x 23½ inches. Courtesy of the Mission Gallery, Taos, N.M.

In his solution to the problem of reducing to a flat surface the effect of distance in its many dimensions, Dasburg has not only relied upon his knowledge of Cubism but has devised a convincing way of evoking the sensation of spaciousness through a blend of force lines and descriptive lines. By making his marks define both the positive and negative spatial aspects of various objects, as well as indicate the direction of movement he wishes our eyes to take, he suggests that a form is present without giving it a complete definition and consequently avoids diffusing the viewer's emotional response with unnecessary elaboration of forms. Thus he

119

maintains the dynamism that has been kindled by an interplay between image recognition and abstract rhythm. There is something splendid about the audacious procedure whereby Dasburg leads us to savor the poetic as well as graphic essense of his motifs. One cannot help but admire and be informed by the way the complex spectacle of nature's basic forces is recalled and brought into congruence by this artist's profound but expressive brevity.

In collaboration with John Sommers, technical director of the University of New Mexico's Tamarind Institute, in Albuquerque, Dasburg began a series of lithographs in 1975 (see fig. 1). Working at first with lithographic crayon on transfer paper, he drew five landscapes in his typical cryptic style. Lines were crisper than in his earlier drawings, for he had begun to use a straight edge in 1974. Sparsely set down were disjointed lines, like those he had found effective in his drawings, but here he made maximum use of tensions evoked by slightly off-parallel marks. When rendering the feeling of space, he played off fragments of information gleaned from studying his motifs against the need to cause his forms to vibrate one with another. Reaffirmed for Dasburg in this new medium was his subordination of nature's details to a measured pictorial experience. He drew these pictures in Taos; then the images were taken by Sommers to Tamarind Institute where they were transferred to lithographic stones, after which proofs were pulled. With the proofs before him Dasburg made additions and deletions on the stones. Other proofs were then pulled, combining the drawings with tone plates in colors provided by Dasburg. When the results were satisfactory, Dasburg signed proofs as an indication that he approved of the prints as they had finally been developed. An edition was then pulled by master printers at Tamarind Institute.

The prints were such a success that, in 1976, a very complicated venture in lithography was undertaken. Dasburg drew on a stone the key elements in what was to become known as *Trees in Ranchitos* (fig. 68). He then made six separate color plates by drawing on Mylar plastic. The resulting images were photographed and transferred to aluminum lithographic plates each of which he completely redrew in crayon. By the addition and deletion of elements in each, he made it possible for all seven images to come together, and, printed one at a time, to make up the complete color lithograph. In this print he brought color to a high pitch reminiscent of the pastels he had done in the 1960s, one of which served as the basis for the lithograph. Contour lines were very alive, and the mixing of the colors from the seven stones resulted in colors that seemed to overflow the forms. That is, in this print the balance between vivid color and studied draftsmanship tilted very much toward color. There is a poetic quality to this lithograph that is very upbeat

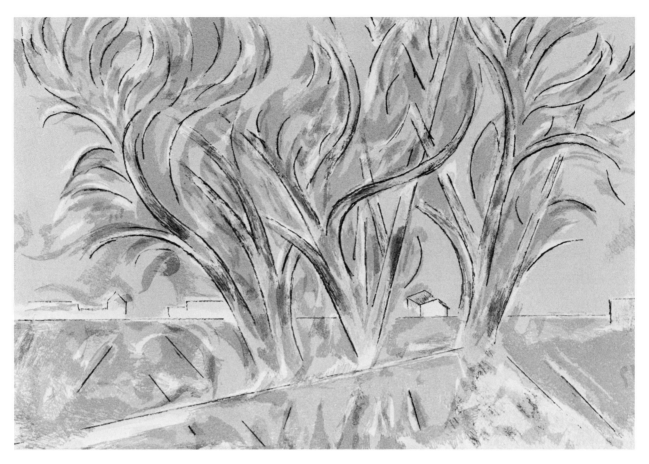

FIGURE 68. *Trees in Ranchitos I*. 1976. Lithograph, 16½ x 23⅜ inches. Tamarind Collection, University of New Mexico Art Museum, Albuquerque, N.M.

and grand. His method of handling the volume of the trees and representing the adobe structure stemmed from a knowledge that allusions to forms in nature made more exciting pictures than detailed renderings of a subject. This print conjures up in one's imagination not just a single scene, but the whole fall season in Taos, when the leaves on the cottonwoods turn golden against the rich blue skies that grace the heavens at that time of year. Five of the separate color plates were printed in two colors each, in a small edition. These are perhaps Dasburg's strongest work in this medium.

Dasburg did two more lithographs in 1977. He used in them a kind of wide-angle vision that conveys a feeling of deep recessional space. One was from a single lithographic plate. For the other, three additional plates were used, one for a

color tone as a background and two more for line and shade. By the disruption of outlines linking different points in these compositions he created a perspective that was convincing and also dynamic as a network of thrusting lines and flat shapes that stood for shadows.

Not to be overlooked in competition with his very strong drawings and lithographs are the pastels Dasburg has done in the last twenty years. In the early 1950s he painted in oil and drew with pastels, a new medium for him, some very different kinds of pictures, less consciously reasoned than his earlier work. They revealed an instinctive impressionistic vigor, a characteristic largely lacking in his pre–World War II work. They seemed to speak more personally of his deep responses to the land as well as of his life after the long period of his serious illness. The significance of these pictures lies in a new use of color as well as form. The lines that knit the compositions together are often irregular, and the representations of the land are more planar than earlier pictures of the same terrain. White was dominant in many of these landscapes. Dasburg liked the work in white being done in Taos at the time by the semiabstract painter Edward Corbett and was also well aware of the white paintings of Thomas Benrimo, a friend of many years. Oils as well as casein gouache were used for these white pictures. Earl Stroh and Benrimo were both using the Shiva white casein gouache that had recently been introduced, and they encouraged Dasburg to try this new water-soluble pigment. It worked well for him; with it he produced some striking results in which touches of bright color enlivened the linear segments of a series of the largely white or off-white compositions.

It was during the 1950s and particularly the 1960s that Dasburg often used pastels. The colors in some of these pictures were dictated by the seasons. Especially strong are some bright yellow and rust red pictures done during the fall when the aspen leaves turn the hillsides into a sea of shimmering gold with touches of red from the leaves of certain vines that grow among the aspens. Often Dasburg would use a sharpened charcoal stick to emphasize a linear break between two colors or two forms. The charcoal stick, being hard and sharp, gives the lines an incised look, which separates them in a dimensional as well as visual fashion from the colorful pastel parts. The result is a flattened and condensed sense of space. Using these new materials and new ideas energized Dasburg as well as his pictures. Underpinning them was his traditional concern for balance and a feeling of plastic density in the forms, but the grid of lines was no longer strict and predictable. What he achieved was a very successful melding of geometry and a kind of organic expressionism. One of the reasons for the new sense of staccato rhythm in the pastels is that they have under the colors an on-the-spot fractured-line quill drawing incorporating the artist's new union of the intellect and the senses.

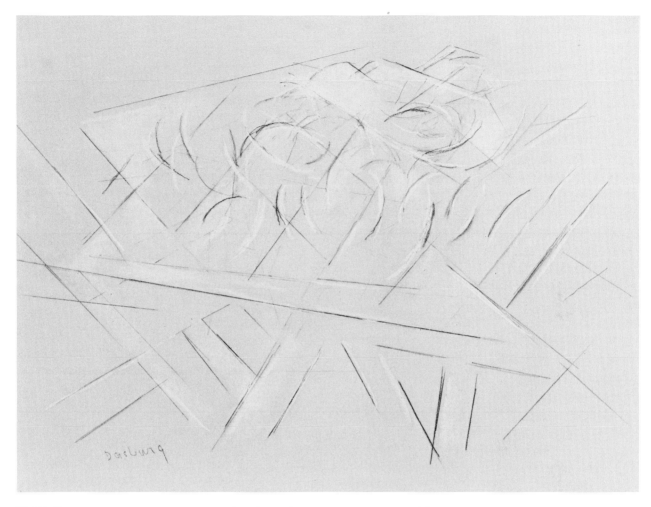

FIGURE 69. *Taos Mountain*. 1979. Pencil and pastel on paper, 16¼ x 23 inches.
Private collection, Taos, N.M.

In his early 1979 work, using soft pencil on gray paper with additions of white pastel, Dasburg has fused what he learned from his spare 1978 lithograph, which was printed on gray, with his more emotional 1950s drawings of swirling forms. *Taos Mountain* is a good example (fig. 69). His response to the snow-covered landscape was very spontaneous. He indicated with pencil the divisions of the fields that cover the plain north of Taos and serve as a table on which sits to the east the sacred Taos Mountain. With the white pastel he has given us a feeling of snow both on the flat ground and in the crevices up the side of the mountain. The exuberance with which the white was applied gives us an idea how he regarded

the subject. Like late Cézannes, these recent drawings give us a great deal with the barest of means. The crisscross of black lines tilted at an angle draws us into the space. The black lines lose their rigidity when the white lines, which form rough ellipses, mingle with them to set up pictorial and emotional surprises. The remarkable thing is that despite the strengths of the design of *Taos Mountain*, it does not get in the way of seeing the true subject—the artist's inner responses to a scene he confronts anew, having known it well for over sixty years. This picture describes the *feelings* of a ninety-two-year-old man about a special place in terms that, while private, can nevertheless be sensed by someone who has never been in New Mexico.

In a broad sense this book has been an assessment of Dasburg the artist and teacher. Mabel Dodge Luhan's statement (p. 50) makes clear the feelings of those artists who studied with him. Now the question of where Dasburg is to be placed in comparison with his contemporaries must be given more attention.

Dasburg was largely trained in New York City and was in and out of the city teaching and painting during the first half of his life, but he was not truly a resident New York artist. He lived in Woodstock and Taos. The environments and attitudes associated with these little art colonies had a major role in shaping the development of his art. In both places he was a dominant figure because of his charm and verve as a person, his natural abilities as a teacher, and the intellectual character of the message he delivered on every occasion. Being *the* dominant modern painter in these art enclaves, which tended to attract less venturesome artists, or artists who needed rest from the rigors of competition in New York, did not provide Dasburg with the challenge that could have extended his ideas and caused him to expand on his earlier innovative work. His master, Cézanne, in contrast, painted in Aix but was frequently in Paris; he had no followers in his native town to bolster his ego and give him a sense of satisfaction with what he was doing. Dasburg always had this kind of support even if it was not associated with financial rewards.

Because he has lived so long, because his middle period appears to have been somewhat lacking in inventiveness—a characteristic that is very important in judging an artist's place in history—and because his late, very strong work is little known, Dasburg has not received the recognition given some of his contemporaries. We tend to forget that, chronologically, he belongs to the generation of such artists as Bernard Karfiol (1886–1952), Thomas Hart Benton (1889–1975), Karl Knaths (1891–1971), Preston Dickinson (1891–1930), Charles Demuth (1883–1935),

Robert Laurent (1890–1970), Stanton Macdonald Wright (1890–1973), William Zorach (1887–1966), Georgia O'Keeffe (b. 1887), and Edward Hopper (1882–1967).

Comparisons with a few of these artists give us perspective on where to place Dasburg in a history of American art. One artist who developed in a fashion comparable to Dasburg was Robert Laurent, three years younger. French born like Dasburg, Laurent was brought to the United States as a young boy by the wealthy connoisseur and patron of the arts Hamilton Easter Field. He returned to Europe and learned the techniques of wood carving while living in Italy. After several years studying sculpture in Europe he came back to the United States while Dasburg was on his first trip to Paris as a mature man. Through Field, Laurent met a number of progressive painters and sculptors. He was the only sculptor in America in the period 1910–20 making wood carvings in a semiabstract vein. His work reflects a knowledge of Cubism and is derived in part from African Negro art, then coming into vogue in contemporary art circles. Human, plant, and animal forms were carved in a highly personal style. Laurent was certainly one of the innovative artists in America in the World War I period. After 1920 he became conservative and executed a considerable number of nude female figure pieces in alabaster and various metals; these have little of the innovativeness of his early work.

Stanton Macdonald Wright, born the same year as Laurent, is another artist who could be compared to Dasburg. He went to Paris two years before Dasburg and, like him, fell under the influence of Cézanne. By 1911 he had developed a synthesis of Cézanne and Impressionism with a special interest in bright colors used to convey a sense of light as an independent agency. Macdonald Wright met Morgan Russell in 1911, and together they studied the color theories of Michel Chevreul and Ogden Rood. In the summer of 1913 they showed their work in Munich under the banner of Synchromism. Later that year their near abstract color discs were shown in Paris at the Bernheim-Jeune Gallery. The following year there was a show of their work at the Carroll Gallery in New York. In 1915 Macdonald Wright moved to London and painted in a truly nonobjective fashion. When he returned to New York, his work received a great deal of attention at the Forum Exhibition in 1916, in 1917 at a 291 show, and in a 1918 show at the Daniel Gallery. The next year he left New York and returned to Los Angeles, where he had lived before he went to Paris. There he continued to paint, but in a much more figurative style; he also took up the study of Oriental art. Like Dasburg and Laurent, he had a burst of innovative energy in the 1910–20 period, then withdrew into a more conservative style.

Dasburg was born the same year as Georgia O'Keeffe. Her art has evolved in a unique fashion. She developed an abstract style during World War I and thereafter moved freely from simplified realism to almost nonobjective art. Her work, furthermore, can be seen to be very American, and it is quite attractive to large audiences owing to her balancing act between figuration and abstraction. Her paintings also reproduce unusually well, a factor not to be overlooked when considering her popularity.

Edward Hopper, another contemporary, is certainly more highly regarded today than Dasburg. A student, like Dasburg, of Robert Henri, Hopper developed a very painterly idiom. While aware of modern European movements, he did not try to incorporate Cubism or the lessons of Cézanne in his work to any marked extent. His deserved recognition was due to his unusual and endearing ability to evoke a feeling of somber loneliness in settings of bright sunlit spaces or neon-illuminated areas. The descendant more of Manet than of Cézanne, Hopper did not open up new avenues with his romantic work. The appeal of his paintings is largely emotional and strikes a responsive chord in critics looking specifically for American qualities in modern art.

The artist of Dasburg's generation who was closest to him in understanding the implications of the modern European movements was Charles Demuth. He went to Paris a few years earlier than Dasburg and studied there longer. When he returned, his personal Cubist interpretations of American architecture received wide critical acceptance. He had Stieglitz's stamp of approval, which made a great deal of difference when it came to critical attention and sales to major collectors of modern art. His were very attractive posteresque paintings that fitted in well with the prevailing Art Deco style but were more systematic than Dasburg's intellectual paintings which stemmed from the same sources. Demuth's congenial work, like that of O'Keeffe and Hopper, also had a special appeal to those who were searching for American characteristics in the period between World War I and World War II. Dasburg's work, on the other hand, always had a European inflection.

When we compare Dasburg to such contemporaries as the sculptors Laurent and Zorach, or painters like Karfiol or Dasburg's follower McFee, all born within five years of him, we find that Dasburg is unquestionably in a different category. These artists all had a period of success and then, unlike Dasburg, settled for a kind of emeritus status. Furthermore, relating Dasburg to American artists of his generation is appropriate, but we must also consider the question of how he relates to modern European art. Dasburg was one of the few Americans, and certainly

among the very earliest, truly to absorb and understand Cézanne, Matisse, and Cubism. He made of what he learned from European art a natural, expressive language. Most Americans were only able to assimilate the surface mannerisms of the modern masters' work. His was a creative use of the canons of modern art rather than an academic adaptation of them.

During the years 1913–16 Dasburg was one of the key figures in American art. If he had not come to New Mexico and chosen to perfect his understanding of Cézanne in that part of the United States that was closest in appearance to Provence, we might have had a different Dasburg. The steep, rugged cliffs of the Sangre de Cristo Range served Dasburg as Cézanne's native landscape served him, but the distance from New Mexico to our country's art center, New York, was much greater than the road from Aix to Paris. The distance from New York was just one factor that determined Dasburg's place in history. And, as we have noted Dasburg had a dull period, the five or six years before he was struck down by Addison's disease. He was "out of sight, out of mind." Even today many people in the New York art world think Dasburg has been dead for a number of years, unaware that he is still very active in Taos.

The painters and sculptors of Dasburg's generation were largely concerned with the treatment of the figure in studio situations. Dasburg was not; neither was he involved with the social statement art of the WPA period, during which time he was in New Mexico, out of touch with the big-city effects of the depression (and later ill and not producing art). Preston Dickinson painted cityscapes and Henry Lee McFee painted landscapes, in modified Cubist styles, but rarely were they as consistent as Dasburg as form makers. The rigor of his alignment with his guiding spirit, Cézanne, produced an art that had, at its best, commanding authority, but after 1931 it was seen only rarely in New York, where the official history of art in America was being formulated. Few of the late, powerful drawings were known in the East.

The angularities he had incorporated in his paintings began to explode in his drawings and pastels of the 1950s and 1960s, as Cubist/Cézanne austerity gave way to nature rearranged in succinct statements that conveyed a sense of dynamism. These pulsating line drawings are a composite of the principles of Cézanne with an expressiveness that is bold and very personal. No stiff Cubism like that found in Knaths's work for Dasburg after 1950, and none of the baroque shanties and twisted trees of Benton's paintings. These were the mannerisms that identified a Knaths or a Benton from across the room. Dasburg's few failures of the 1950s and 1960s were those of a daring artist who did not follow the safe path taken at the age of

sixty-five by the majority of his well-known contemporaries. His rough, energy-evoking lines took on some of the calligraphic verve found in Franz Kline's black-on-white paintings. Dasburg's drawings also evoke the breadth and scale of the layered landscape near Taos in a fashion that is at times close to Willem de Kooning's drawings. Like Dasburg, de Kooning rarely broke with the sources of his imagery. Dasburg's, however, was an independent development along similar lines, not a response to the canons of Abstract Expressionism but just as expressive of the artist's emotions. By the time he had achieved mastery over his new direction he was no longer represented by a New York gallery, nor was his late work included in New York museum exhibitions. Critics in New York were therefore unaware of the drawings that link Dasburg in broad terms to the aims of the Abstract Expressionists.

Who did respond to this late work? It is to the credit of the people of Taos and visitors to that community that his drawings have been continuously bought from local galleries almost as fast as they were finished, making it unnecessary to promote the work in larger centers. This situation, while gratifying to the artist, precluded professional critical evaluation of the late work until a large selection was shown in various museums in 1966. At that time Alfred Frankenstein described Dasburg as "the greatest landscape draughtsman since Van Gogh," a judgment borne out by even more recent work as the artist's measuring mind has extracted from New Mexico's mystic landscape more and more of the secrets of its formal roots as well as the qualities that have made it truly a land of enchantment and a supreme pictorial challenge.

Notes

1. Alfred Frankenstein, *San Francisco Sunday Examiner and Chronicle,* "This World" section, April 17, 1966, p. 24.

2. Dasburg became an American citizen in 1922.

3. Recollections of Andrew Dasburg (typescript, 6 unnumbered pages, c. 1972). Hereafter cited as "Recollections."

4. In the early years of the Art Students League the spelling of the name varied from *Students'* to *Students.* The latter will be used in this book.

5. Allen Tucker, "The Art Students' League—An Experiment in Democracy," *The Arts* 6(1924):265.

6. From correspondence between and related to Andrew Dasburg and Grace Mott Johnson in the collection of their son, Alfred Dasburg. Hereafter cited as "Correspondence."

7. Ibid.

8. Ibid.

9. Author interview with Dasburg, September 1978.

10. Correspondence.

11. Author interview with Dasburg, September 1978.

12. Ibid.

13. Correspondence.

14. Ibid.

15. Ibid.

16. Ibid.

17. *Lucifer* was destroyed when Dasburg moved west because, as he said in September 1978, he no longer had room for him in his life.

18. Recollections.

19. Correspondence.

20. Ibid.

21. Ibid.

22. Ibid.

23. Mabel Dodge Luhan, *Movers and Shakers* (New York: Harcourt, Brace & Co., 1936), p. 249.

24. Ibid., p. 83.

25. Ibid., p. 250.

26. Ibid., p. 249.

27. Ibid., p. 251.

28. Ibid.

29. Ibid., p. 250.

30. Correspondence.

31. Ibid.

32. Ibid.

33. Ibid.

34. Ibid.

35. Luhan, *Movers and Shakers,* p. 256.

36. Ibid., p. 273.

37. "News of the World of Art: Post-Futurists Having Fun with Themselves and The Public in Several City Galleries, *New York World,* February 8, 1914.

38. Ibid.

39. Recollections.

40. Ibid.

41. Catalog, Forum Exhibition, Anderson Galleries, New York, N.Y., March 13–25, 1916.

42. Helen Chase Drea to author, February 26, 1976.

43. Maurice Sterne, *Shadow and Life: The Life, Friends and Opinions of Maurice Sterne* (New York: Harcourt, Brace & World, 1952), p. 130.

44. Ibid.

45. Ibid., p. 133.

46. Mabel Dodge Luhan, "Georgia O'Keeffe in Taos," *Creative Arts,* June 1931, p. 407.

47. Recollections.

48. Correspondence.

49. Ibid.

50. Author interview with Dasburg, September 1978.

51. Correspondence.

52. Ibid.

53. Mabel Dodge Luhan, *Taos and Its Artists* (New York: Duell, Sloan & Pearce, 1947), p. 16.

54. Charles Eldridge, *Ward Lockwood* (Lawrence: Regents Press of Kansas, 1974), p. 25.

55. Luhan, *Taos and Its Artists,* p. 16.

56. Recollections.

57. Andrew Dasburg, "Cubism: Its Rise and Influence," *The Arts* 4(1923):278–84.

58. Alexander Brook, "Andrew Dasburg," *The Arts* 6(1924):19–26.

59. H. E. Schnakenberg, "Andrew Dasburg," *The Arts* 7(1925):168.

60. Correspondence.

61. Ibid.

62. Quoted in John O'Connor, Jr., "The Kane Memorial Exhibition," *Carnegie Magazine,* April 1936, p. 21.

63. Details about this painting were derived from a visit with and letter to the author from Loren Mozley, February 1978.

64. Elizabeth Cary, "Progression Through Cubistic Influences to Personal Expression—A Delicate Art," *New York Times,* Arts section, March 18, 1928, p. 14.

65. Author interview with Dasburg, September 1978.

66. Ward Lockwood, "Statement," in *Andrew Dasburg* (Dallas: Museum of Fine Arts, 1957), unnumbered pages.

67. Correspondence.

68. Information on late 1940s and 1950s based on an interview with Antonia Mygatt Lucas conducted in November 1978.

69. Correspondence.

70. Regina Cooke, "Stroh Remembers Art Lessons with Dasburg," *Taos News*, October 5, 1978.

71. Charles Moffatt Kassler to author, March 30, 1978.

72. Andrew Dasburg, "New Mexico and the Arts," *New Mexico Quarterly* 21(1951):249–53.

73. Dasburg, "Cubism: Its Rise and Influence."

74. Many of the comments on Dasburg's drawings were first published in Van Deren Coke, *The Drawings of Andrew Dasburg* (Albuquerque: University Art Museum, 1966).

Bibliographic Note

Most significant bibliographic references appear in the notes. Two recent articles are Gail Levin, "Andrew Dasburg: Recollections of the Avant-Garde," *Arts Magazine* 52, no. 10 (June 1978): 126–30, and Mary Carroll Nelson, "Andrew Dasburg: Taos Maverick," *American Artist* 43, no. 441 (April 1979): 64–69, 112–15.

Chronology

1887	Born in Paris, France.
1889	Father dies. With mother moves to Nittel, Germany, near old family home on the Luxembourg border.
1891	Falls from loft and injures hip.
1892	Comes to the United States with his mother, whose sister and brother-in-law are already established in New York City. Lives with mother's sister, whose husband is a marble polisher. Mother becomes a seamstress; there is little money in the family.
1892–93	Has a fall in a street excavation while playing. Injury suffered to left hip, does not heal properly. Falls behind in public school due to being often bedridden.
1894–1901	Attends a New York City school for crippled children. There learns to work wood and metal and to draw in manual training classes. Taught art by a woman named Miss MacKenzie. During this period he has to wear metal hip and leg braces for five or six years.
1902	Miss MacKenzie takes Dasburg to Art Students League, where he begins instruction in drawing from plaster casts of classic sculpture under the director of Kenyon Cox. Walks four blocks to and from Art Students League for his morning classes despite hip injury.
1904	Begins painting in the life class of Frank Vincent DuMond at Art Students League. Takes night classes under Robert Henri.
1906	Awarded landscape painting scholarship by Art Students League for summer program taught by Birge Harrison at Woodstock, N.Y. Harrison emphasizes muted colorations and romantic subject matter such as moonlight scenes or landscapes on a gray day.
1907	Boards during summer and into fall at Rock City, near Woodstock. The painter and sculptor Charles Morgan Russell is his fellow boarder.
1908	Makes walking tour from Boston to New York with Russell and Grace Mott Johnson.
1909	Spends six weeks at beginning of the year in Boston, studying anatomy from life at Boston Museum School and from books in Boston Public Library.

1909–10	Goes to Paris where his friend Russell has taken classes with Matisse. Russell arranges for Dasburg to meet Matisse and see him work in his studio. Meets Leo and Gertrude Stein. At their house meets Picasso and other French artists. Becomes acquainted with Cézanne's paintings at Vollard's gallery in Paris. In mid 1909 marries Grace Mott Johnson in London with their friend the sculptor Arthur Lee as witness.
1910	Helps mother and aunt buy house in Wurtsboro, N.Y. Spends fall repairing it.
1911	Son Alfred born in Yonkers, N.Y.
1912	Johnson buys house and studio in Woodstock. Dasburg prepares it for residence.
1913	In the spring has three paintings (executed in 1912) and a piece of sculpture (*Lucifer*) included in the Armory Show. Wife's sculpture is also included in the Armory Show. In late summer and fall in Woodstock does first near-abstract paintings for Macdowell Club exhibition after talking at length with Konrad Cramer about the possibility of using ideas from color charts and chromatic scales. In November has 7 works, 5 paintings and 2 "sketches," included in exhibition of paintings and sculpture at the Macdowell Club in New York City. Exhibited are works with titles such as *Chromatic Chiaroscuro, Chromatic Chiaroscuro Improvisation in Red and Blue.* Konrad Cramer exhibits 6 *Improvisations* in the show. At Macdowell Club meets John Reed, who is living with Mabel Dodge, and his friend, Robert Edmund Jones. They invite Dasburg to meet Mabel Dodge at one of her Thursday Evenings. Titles painting *Absence of Mabel Dodge* upon finding her gone when he attends first "evening" at her apartment. Invited to show at Union Internationale des Beaux Arts et des Lettres, Paris.
1913	In summer spends six weeks on Monhegan Island, off Maine, where he finds his friend George Bellows at work.
1913–16	Paints semiabstract, Cubist-influenced pictures including three "portraits" of Mabel Dodge and in 1916 one titled *Sermon on the Mount.*
1914	Spends two weeks as Mabel's guest in Provincetown, Mass. Stieglitz photographs Dasburg and Cramer. With help of Johnson's bequest from her grandmother, Dasburg goes to Paris in the late summer for a four-month stay. Returns to New York City in December as the result of the disruption caused by the beginning of World War I.
1915	Exhibits at Macdowell Club in New York City. Mabel Dodge buys Finney Farm at Croton-on-Hudson in New York State, where Dasburg does many drawings and paintings in the next five years.
1916	Work is included in Forum Exhibition at Anderson Galleries in New York City. With Henry Lee McFee does stage setting for Maverick Festival in August.
1917	Teaches a sketch class from model with his friend and follower McFee during May and into summer at Woodstock. In winter holds a class at his studio on 9th Street in New York City. In fall teaches a private class in New York City, at 64 West 39th Street. Grace Mott Johnson and Dasburg separate but remain close friends.
1918	Living in private quarters at Mabel Dodge's New York City apartment. Accepts her invitation in January to come to New Mexico. Travels to Taos with stage designer Robert Edmund Jones and a German male cook whom Mabel Dodge had asked the two men to hire and bring with them. Becomes interested in Indian and Spanish-American artifacts; begins to collect them for sale. Explores the Taos region on foot

and horseback. Does some sketches, including some work in Maurice Sterne's studio, of Indians that Sterne is drawing and modeling. Remains in Taos until May 6.

1920–33	Spends part of almost every year in New Mexico; the remainder of these years are spent in or near Woodstock, New York, or in New York City.
1920–21	Teaches summer classes at Woodstock, New York.
1922	Becomes naturalized citizen of United States. Divorces Grace Mott Johnson and begins living with Ida Rauh.
1923–30	Becomes part-time resident of Santa Fe.
1923	His article "Cubism: Its Rise and Influence" is published in *The Arts*.
1924	Alexander Brook writes "Andrew Dasburg" for *The Arts*.
1925	Awarded second prize at the Pan American Exhibition in Los Angeles.
1926	With B. J. O. Nordfeldt, Witter Bynner and others founds the Spanish and Indian Trading Company to sell artifacts and crafts.
1927	Serves as member of jury of acceptance for 26th Carnegie International Exhibition in Pittsburgh. Awarded third prize. First prize goes to Matisse.
1928	One-man exhibition at Frank K. Rehn Galleries in spring in New York City. Marries Nancy Lane in December. Spends four months with her in Puerto Rico painting.
1929	He and Nancy build house in Santa Fe. Sees a good deal of John Marin, who spends summer in Taos as Mabel Dodge Luhan's guest.
1930	Visits Taos. During summer again spends a good deal of time with John Marin, who paints in New Mexico for about three months. Work from New Mexico is included in Frank K. Rehn Galleries show in New York City.
1931	One-man exhibition at Rehn Galleries. Is awarded Allegheny Garden Club Prize in the Thirtieth Annual Carnegie International Exhibition of Paintings for *Bouquet*.
1932	Awarded Guggenheim Fellowship for study in Mexico. Spends about three months there drawing and painting in watercolors. Much time spent in Taxco, where he is guest of John Evans, Mabel Dodge's son, who has a house there. Divorces Nancy.
1933	Marries Marina Wister. They buy and remodel an old house and studio in Taos. Becomes permanent resident of New Mexico.
1937	Becomes victim of Addison's disease, which is so debilitating that he has largely to give up painting. Spends time in Bryn Mawr, Pennsylvania, at his wife's home.
1943	Gains strength after receiving newly developed treatment for Addison's disease. Starts painting and drawing again.
1945	Marina Dasburg goes back east upon death of her father and never returns to New Mexico.
1952	Has a minor stroke but continues to work.
1957	One-man exhibition of 111 works held at Dallas Museum of Fine Arts.
1958	Awarded honorary Doctorate of Fine Arts by the University of New Mexico.
1959	Ford Foundation makes possible a retrospective exhibition circulated for two years by the American Federation of Arts.
1966	"Taos Collects Dasburg" Retrospective exhibition of 70 paintings and drawings at

the Stables Gallery of the Taos Art Association. An exhibition "The Drawings of Andrew Dasburg" is held at the Art Museum, University of New Mexico. This exhibition is also shown at DeYoung Museum, San Francisco, and Amon Carter Museum of Western Art, Forth Worth.

1970 Has a cataract operation.

1975 Exhibition of a selection of work at Governor's Gallery, Santa Fe.

1976 Receives Governor's Arts Award and has exhibition in Santa Fe at Governor's Gallery.

1978 Retrospective exhibit at Mission Gallery during Taos Arts Festival.

Works of Andrew Dasburg, Other Than Prints, in Public Collections

Art Museum, University of New Mexico, Albuquerque, N.M.
 Untitled (landscape), 1910, oil
 Female Nude, 1923, pencil and pastel
 Puerto Rican Beach, 1928, watercolor
 Puerto Rican Plantation, 1928, oil
 Sangre de Cristo Mountains, 1928, oil
 Hondo Canyon, 1932, watercolor
 Landscape, 1933, watercolor
 Joe Mondragón, 1939, pencil
 Fruit Still Life, 1949, ink, crayon, pastel
 Llano Quemado, 1950, pencil
 Bulbs, c. 1950, ink
 Sage Flats West, 1961, ink
 Ranchos de Taos Church, 1970, pencil
 Llano Quemado, 1970, pastel

Barnes Foundation, Merion Station, Pa.
 Mountain Landscape, late 1920s, oil

Cincinnati Art Museum, Cincinnati, Ohio
 Ramoncita, 1927, oil

Colorado Springs Fine Arts Center, Colorado Springs, Colo.
 Mural, 1937
 Trees, n.d., brown Conte crayon

Dallas Museum of Fine Arts, Dallas, Tex.
 Judson Smith, 1926, oil
 November, New Mexico, 1933, watercolor
 Early Snow, 1955, ink and wash
 Fields of Llano Quemado, 1956, oil

Denver Art Museum, Denver, Colo.
 Chantet Lane, 1926, oil
 Portrait of Cecil, 1926–27, oil

Fort Worth Art Museum, Fort Worth, Tex.
 Sage Flats, 1961, ink

Harwood Foundation, Taos, N.M.
 Autumn Fruit, 1934, oil
 Roundabout—Kingston, New York, n.d., oil

Helen Foresman Spencer Museum of Art, The University of Kansas, Lawrence, Kans.
 Taos Valley, 1928, oil

The Helen Wurlitzer Foundation, Taos, N.M.
 Tree Study, San Antonio, Texas, c. 1939, pencil
 Orchard, 1950, ink
 South of Taos, 1955, ink

Hirshhorn Museum and Sculpture Garden, Washington, D.C.
 Poppies, c. 1923, oil

Los Angeles County Museum of Art, Los Angeles, Calif.
 Tulips, 1923, oil

Marion Koogler McNay Art Institute, San Antonio, Tex.
 Study for Mural in Colorado Springs Fine Arts Center, 1937, pastel

Metropolitan Museum of Art, New York, N.Y.
 Road to Lamy, 1924, oil
 Three Spoonbill Ducks, 1927, oil

Museum of New Mexico, Santa Fe, N.M.
 New Mexican Village (or *Taos Houses*), 1926, oil
 My Gate on the Camino, 1928, oil
 Fruit Still Life, 1931, watercolor
 Landscape, 1932, ink
 Aspens, 1932, oil
 Trees, 1938, pencil
 Untitled, 1959, ink
 Cottonwoods, n.d., oil
 Landscape, n.d., ink
 Portrait of Chas. Augustus Ficke, c. 1928, oil
 Sangre de Cristo, n.d., watercolor

Nebraska Art Association, Lincoln, Nebr., held in the collection of the Sheldon Memorial Art Gallery, University of Nebraska
 Pueblo Mountain, 1953, ink

Roswell Museum and Art Center, Roswell, N.M.
 Sermon on the Mount, c. 1916, watercolor

San Francisco Museum of Modern Art, San Francisco, Calif.
 Landscape, c. 1927, oil

Santa Barbara Museum of Art, Santa Barbara, Calif.
 Winter Landscape: New Mexico, 1931, oil
 Afternoon, New Mexico, 1933, watercolor

Sheldon Memorial Art Gallery, The University of Nebraska, Lincoln, Nebr.
 Avocados, 1931, oil
 East of Santa Fe, 1932, watercolor
 Village on the Hill, 1966, ink
 Portrait of Henry Lee McFee, n.d., pencil
 Trees, 1969, ink

Taos Municipal School System, Taos, N.M.
 Picuris Mountains, 1947, pencil

Whitney Museum of American Art, New York, N.Y.
 Landscape, 1920, pencil
 Apples, 1929, oil
 Spring Landscape, c. 1930, watercolor
 Taxco, 1933, watercolor
 Tulips, 1934, brown Conte crayon
 Orchard in a Windstorm, 1949, ink
 Orchard—The Trees, 1950, ink
 Orchard Drawing—Things Setting Spaces in Motion, 1950, ink

William Rockhill Nelson Gallery of Art, Kansas City, Mo.
 Portrait of Loren Mozley, 1928, oil

Index